Assembling Panoramic Photos

A Designer's Notebook

Assembling Panoramic Photos

BERTRAND **BODIN**

ARNAUD **FRICH**

ALBERT **LEMOINE**

CHRISTOPHE **NOËL**

SACHA **POPOVIC**

PEET **SIMARD**

LAURENT **THION**

GILLES **VIDAL**

TRANSLATED BY

WILLIAM **RODARMOR**

O'REILLY®

Beijing • Cambridge • Farnham • Köln • Paris • Sebastopol • Taipei • Tokyo

Assembling Panoramic Photos: A Designer's Notebook
by Bertrand Bodin, Arnaud Frich, Albert Lemoine, Christophe Noël, Sacha Popovic, Peet Simard,
Laurent Thion, and Gilles Vidal

Translated by William Rodarmor

Published by O'Reilly Media, Inc., 1005 Gravenstein Highway North, Sebastopol, CA 95472.

Translation from the French language edition of: *Photos panoramiques par assemblage - Cahier du Designer
17* by Bertrand Bodin, Arnaud Frich, Albert Lemoine, Christophe Noël, Sacha Popovic, Peet Simard, Laurent
Thion, and Gilles Vidal. © 2004 Editions Eyrolles, Paris, France.

O'Reilly books may be purchased for educational, business, or sales promotional use. Online editions are
also available for most titles (*safari.oreilly.com*). For more information, contact our corporate/institutional
sales department: (800) 998-9938 or corporate@oreilly.com.

Editor:	Robert Luhn
Production Editor:	Darren Kelly
Art Director:	Michele Wetherbee
Cover Designer:	Volume Design, Inc.
Interior Designer:	Anne Kilgore

Printing History:

May 2005:	First Edition.

ISBN: 0-596-00975-5

[L]

Contents

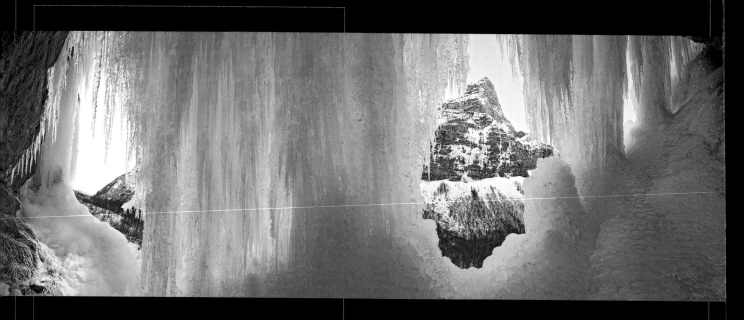

I have a deep commitment to nature photography and to landscape photography in particular. So when the Département des Hautes-Alpes regional council gave me an assignment for a book, I decided to showcase the incredible diversity of the department's alpine landscapes. Panoramic photography seemed like a natural choice, and I chose an image assembly technique that mimics what the human eye perceives and senses at the margins of its field of vision—the realm of what I call "perceptual photography."

Using Photoshop to assemble panoramas lets you create photographs that are wider than 180° but still have acceptable proportions: a 1:3 height-to-width ratio, which is the same as a 2.4 x 6.7 in. (6 x 17 cm) panoramic camera such as a Linhof (whose field of view is only 105° wide).

Studio 01

BERTRAND **BODIN**

Hardware used
- Canon EOS-1Ds digital camera
- 70–200mm zoom lens, 14mm wide angle lens
- Benbo tripod
- Manfrotto 302 panoramic head
- PC with 3GHz Pentium 4 processor and 1 GB of RAM
- 19-in. Iiyama monitor

Software used
- Photoshop CS

Waterfalls of Ice

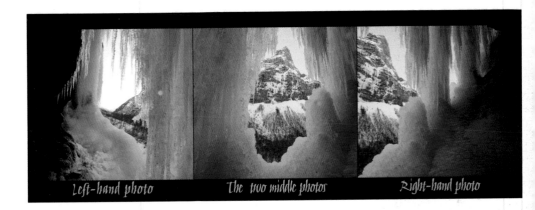

Left-hand photo The two middle photos Right-hand photo

As an example of an Hautes-Alpes mountain valley, I chose the Fressinière Valley in Ecrins National Park, the mid-winter gathering place of an international group of mountaineers called the Ice Climbing Ecrins. My idea was to show a world of ice where frozen waterfalls were part of the landscape. I scouted the location carefully, because I wanted to include a recognizable mountain to help identify the locale; I chose the Tête de Gramuzat, which appears between two of the icefalls.

I took advantage of the fact that the valley gets no direct sun in January, which emphasizes the feeling of cold already present due to the bluish waterfalls and the white and gray of the mountain.

The reflection of the blue sky on ice

gives these frozen waterfalls their special, dreamlike color.

Stage 1

Before taking the pictures

The day was bitterly cold (5°F, -15°C), so I paid close attention to my equipment. I fully charged the two Canon batteries and kept a spare battery warm so I wouldn't run out of power. I used crampons to walk safely on the mountain and move around behind the icefalls, which I reached after a half-hour hike. The space between the rock wall and the curtain of ice was fairly shallow (about five feet). Because of the limited space, and my desire to frame the mountain in a window in the ice, I had to use an extreme 14mm wide-angle lens mounted in front of the Canon's 24 x 36mm CCD sensor.

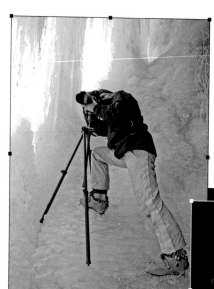

Shooting the pictures properly is the most important stage in any successful panorama.

The best feature of the Canon EOS 1Ds is its 24 x 36mm imaging area (equal to a standard 35mm SLR), which makes it possible to use the 14mm lens's full 114° field of view. Horizontal coverage was determined by the number of shots I would need to cover the full width of my chosen view—in this case, four photographs to cover an arc about 200°.

The Benbo tripod is handy for a variety of shooting situations in the field. In this case, I set up the tripod and camera so the mountain could be seen between the icefalls. I attached the Canon vertically, made sure the lens's nodal point was above the rotation axis of the Manfrotto panoramic head, and used levels to check the horizontal and vertical alignment.

Despite the 114° vertical field, the frame still didn't include the summit of the mountain. So for shot number 3—and for that shot only—I tilted the camera slightly upward. I would correct the distorted perspective in Photoshop later.

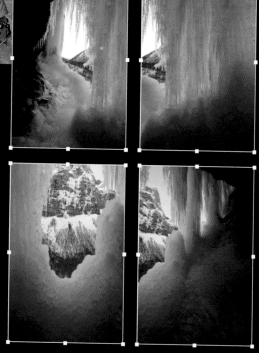

Stage 2

Shooting and digitizing the pictures

I set the camera to maximum resolution and slight JPEG compression; the white balance manually to 5500 K, a color temperature that corresponds to Fuji Velvia film; the camera's sensitivity to 100 ISO; and exposure to manual mode.

Choosing the right white balance **was essential**

to getting the beautiful blue of the ice.

I stopped the diaphragm down to f-14 to get plenty of depth of field. (Stopping it down further would have caused increased aberration and diffraction problems, and produced a less sharp photograph.)

Using the 70–200mm zoom lens in spot mode, I took a light meter reading on the white snow at the foot of the mountain, and increased it by two stops, to $\frac{1}{13}$ second. I shot the four pictures with the same settings, without adjusting for the lighter values in the center of the first picture or the darker values at the right of the fourth one.

The four pictures were taken with a partial overlap of 10– 20%. I carefully framed them so that their edges were in parts of the ice curtain and not the mountain, to avoid any trouble in assembling the pictures due to my choice of the 14mm lens.

It took me three hours of shooting and 98 shots to produce enough different pictures to give me a choice of the four best.

Back at my car, I checked the data I'd transferred from the camera's flash cards to my laptop's hard disk. I wanted to make sure the intense cold hadn't affected the data.

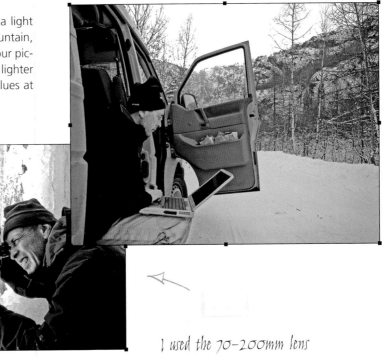

I used the 70–200mm lens to get a more accurate spot meter reading.

Stage 3

Assembling the images

I planned to assemble the four images in Photoshop starting with the image on the right, so I opened picture 4. You'll notice that I placed Photoshop's tools outside of the canvas so that they wouldn't interfere with the image, while keeping all of the menus displayed.

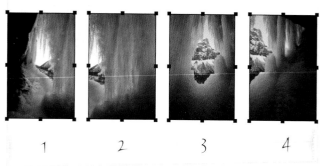

1 2 3 4

Each photograph produced by the Canon EOS 1Ds was 9 × 13.5 in. (22.89 x 34.41 cm) at 300 dpi. I opened picture 4, then resized the canvas using Image→Canvas Size to 36 in. (92 cm) wide (four times the width of the photos) and 15.7 in. (40 cm) high. In the same dialog box, I clicked the center-right arrow (in the 3 o'clock position) and then clicked OK.

I then opened picture 3, selected it (Ctrl-A), and dragged it onto picture 4 with the Move tool; this created a new layer (Layer 1). I repeated the same operations for pictures 2 and 1.

The perspective in picture 3 was distorted when I tipped the camera up, so I had to straighten the two curtains of ice on either side of the mountain to make them perfectly vertical, as in the other pictures.

In Layer 1 (which held picture 3), I pressed Ctrl-T to summon the Free Transform function, and, while holding the Ctrl key down, pulled the upper corners up and out to warp the picture and straighten the perspective. I then moved the whole photo up a bit.

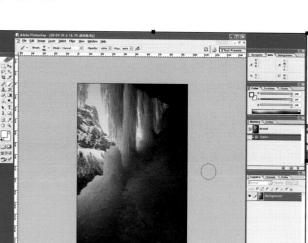

Photoshop's tools have been moved outside of the canvas.

For a photograph to be as realistic as possible,
everything depends on the subtlety of your manipulations.

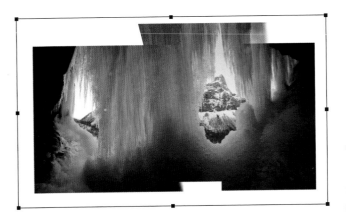

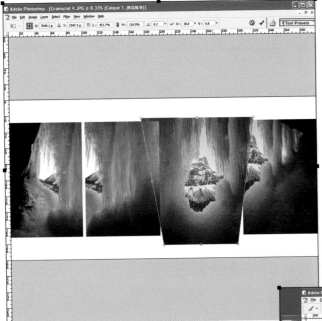

I then repeated all these operations for the last two pictures.

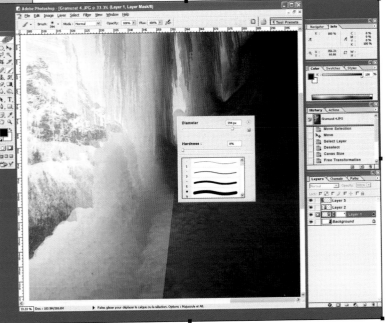

I set Layer 1 in Multiply mode, then adjusted the overlap of picture 3 to match the background.

Once the alignment was correct, I locked Layer 1 in position, and added a layer mask. I chose a soft-edge, 394-pixel brush with 100% opacity. I erased the right part of the layer, being careful not to let the seam between the first two pictures show through. I then set the layer in Normal mode and turned off the background to reveal the feathering along its edge. I continued to increase the feather by adjusting the Brush tool's diameter to 100 and opacity to 20% until the junction between the two pictures was invisible, even at 100% zoom.

Stage 4

Cropping and corrections

I re-cropped the entire panorama to eliminate the parts I didn't want, then flattened the final image.

Be careful—once an image is flattened, there's no going back. It's a good idea to first save the image with all its layers in PSD format.

The resulting image was 29.5 x 13.7 in. (75 x 35 cm) at 300 dpi. I had to change this to a 1:3 ratio for the assignment, so I cropped it to 29.5 x 9.8 in. (75 x 25 cm). The resulting file size was big enough that I could create a banner-sized digital print (8 x 25 ft. or 2.7 x 7.5 m) for an outdoor display.

I copied the background, created a new layer, then used the Clone Stamp tool to eliminate some dust that showed up on the camera's CCD sensor. I also had to erase a few water droplets; water in the ice cave had dripped onto the protruding 14mm lens, despite my efforts to protect it.

The Shadow/Highlight command sliders.

The resulting photograph was beginning to look the way I'd hoped. All I had to do now was adjust the color. I then called on Photoshop CS's powerful Shadow/Highlight tool, which made it easy to correct under- and over-exposed areas.

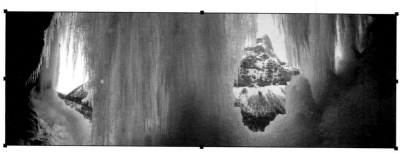

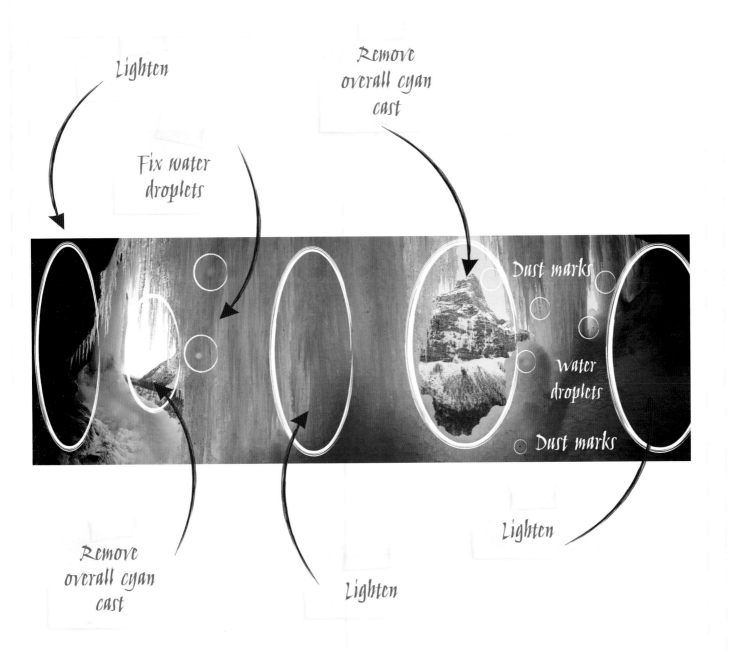

Lighten

Remove overall cyan cast

Fix water droplets

Dust marks

Water droplets

Dust marks

Lighten

Remove overall cyan cast

Lighten

Stage 5

Optimization and color adjustment

To refine the picture's density and color, I first selected the sky with the Magic Wand tool. Then I selected the Magnetic Lasso and pressed the Shift key to add to the earlier selection. To refine the selection further and precisely select the ice windows, I pressed the Alt key to subtract parts of the selection with the Magnetic Lasso. I then applied a 3-pixel feather, and saved the selection under the name Windows.

To eliminate the cyan cast on the background landscape, I created an adjustment layer with the Curves tool (Layer→ New Adjustment Layer→Curves) and set the white for the snow at the base of the mountain. I then pulled the curve down a little to increase the picture's density.

I duplicated the Background copy layer, and chose the Dodge tool set for Highlights and 8% exposure. Working like a painter and using small strokes with the Brush tool, I lightened the stalactites and frozen grass on the left, some of the lightest parts of the ice curtains, and a small area on the right.

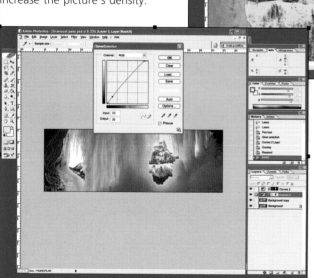

By turning Background copy 2 alternately on and off, I could see the effect of my adjustments.

Each time I finished adjusting a layer or a layer mask, I checked the picture's intensity and color balance correction by turning the layer on and off.

I retrieved the selection, inverted it, and created a curves adjustment level to lighten the curtains of ice. I then selected the blue color and intensified it very slightly.

S t a g e 6

Finishing the panorama

I saved the picture in Photoshop to preserve all the layers, then flattened it. I then applied Filter→Sharpen→Unsharp Mask, set the values for eventual printing, and saved the final photograph in TIFF format.

I achieved exactly what I'd envisioned and hoped for before I started shooting. I chose the locale for the contrast in color and textures between the foreground and the mountain in the distance. The hard part was mentally visualizing exactly how I would overlap photographs to cover a 200° field of view.

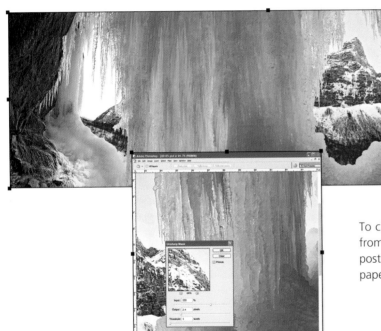

To check the final picture's quality, I made a film-based proof from my digital file, and ran off a little presentation sample in poster format at 13 x 37 in. (33 x 95 cm). Printed on glossy paper, the result was spectacular! ▪

The resulting file was
29.5 x 9.8 in.
(75 x 25 cm) at 300 dpi.
In an uncompressed TIFF
format, it was 74.8 MB!

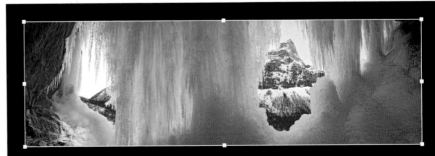

Fressinière Valley, Hautes-Alpes, Bertrand Bodin

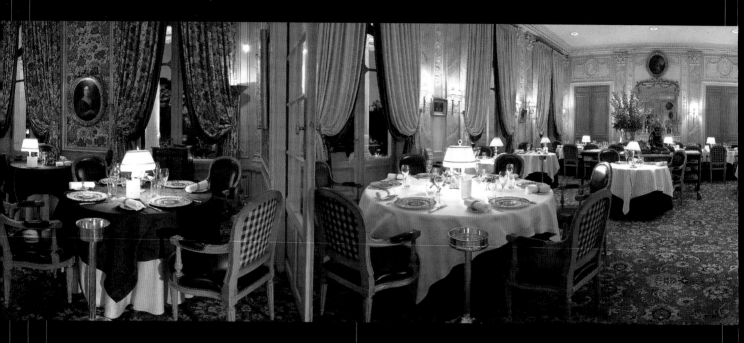

Sometimes only a panoramic photograph can
do justice to the richness of certain locations.
When the subject lends itself to it, you can
sometimes even tell several stories within the
same picture, which was the case with this
beautiful restaurant dining room. To create
the photograph, I had to solve two purely
technical problems. They weren't necessarily
specific to panoramic photography, but rather,
were inherent to this very distinctive locale.

Studio 02

ARNAUD **FRICH**

Hardware used
- Canon EOS-1D digital camera
- 28mm lens
- Manfrotto QTVR 303SPH panoramic head
- PC with 3GHz Pentium 4 processor and 2 GB of RAM
- Wacom graphic tablet
- Two 17-in. liyama monitors

Software used
- Photoshop 7
- PanaVue ImageAssembler 2.12

At the Restaurant

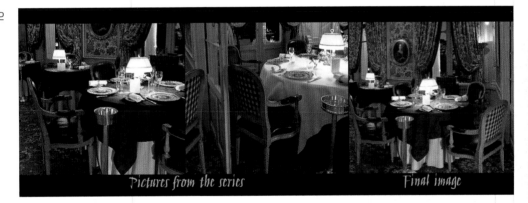

Pictures from the series *Final image*

When I was commissioned to shoot a panorama of the gourmet restaurant Château Les Crayères in Reims, I wanted to avoid two common photographic pitfalls. In many assembled panoramas, the horizon line runs across the middle of the photograph. This always results in showing too much of the ceiling, which usually isn't very interesting. I also wanted to avoid the harsh contrasts that often occur between the inside and the outside of a building, as well as near light sources. For this project, I left my panoramic Noblex 150 film camera behind, opting instead for the possibilities and composition choices offered by today's digital tools: significant lens perspective correction to keep lines vertical, choice of field of view, multiple exposures, etc.

The resulting panoramic photograph was published
on the hotel's web site and printed at 300 dpi in a brochure.

Stage 1

The best time to shoot?

I would be on location in Reims for only a day, so I had to decide the best time to take the photographs. I quickly chose the end of the day, when the bluish twilight outside would blend nicely with the warm lighting of the room. This would also allow me to avoid having overly bright halos around the windows.

I then had to solve the other major problem inherent in photographing interiors: the glare on areas close to artificial light sources, such as the table in the right foreground. This phenomenon is often made worse by digital cameras, which can quickly turn highlights into hot spots. The simplest way to solve the problem is to shoot two identical photographs at different exposures, use Photoshop to combine the images, and use the resulting picture as part of the assembled series in the final panorama.

To assemble a panorama, a number of applications can stitch together photos without visible seams. The programs vary, of course, but they all work much better if the adjacent photographs overlap by 15–20% and are taken from the same vantage point, with the lens's entry point located precisely above the rotation axis. (The lens entry point is the point inside a camera lens where the light paths cross before being focused on the film plane. On fixed-length lenses—but not zoom lenses—it is the same as the nodal point.)

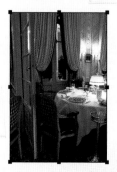
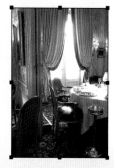

At midday, the halo around windows is very difficult to eliminate, even when you use two superimposed photographs.

A panoramic head?

Today's panorama assembly programs are so powerful they can create montages that are very hard to distinguish from a photograph taken with a true panoramic film camera. Combined with Photoshop's masking, retouching, and blending capabilities, you can create extremely realistic-looking photographs without a big financial investment.

I used a Manfrotto QTVR 303SPH panoramic head with three sliding plates. Even when the camera is tilted, its lens entry point remains exactly above the pivot point, so the perspective doesn't change.

Sliding plates and a rotation index guide on the Manfrotto head make it very easy to rotate the camera the exact number of degrees required for pictures at a given focal length.

How many pictures?

For this project, I would need to take five photographs with a 28mm lens (or six with a 35mm) to match a Noblex's field of view—about 135° horizontally—while preserving a 15% overlap between the pictures. Most stitching programs can only do their calculations correctly if the horizon line is in the center of the photograph. That wasn't appropriate for this project, since I wanted to point my camera slightly downward. So I decided to use one of the few assembly programs that gives you complete freedom in shooting: PanaVue Image-Assembler 2.12.

Warning – don't use a perspective correction lens! Just use your camera normally and tilt it up or down, depending on what part of the picture you want to emphasize or hide; the software will correct the perspective automatically. In this picture, the vertical lines are clearly converging downward.

S t a g e 2

What exposure?

With most assembly programs you have to shoot all the pictures in a series at the same settings, with identical exposure, focus, and white balance. With ImageAssembler you can correct the exposure slightly—by about a third of a stop—between consecutive shots without it being apparent. This was very useful here, given the strong light level differences between the rooms. The two left-hand photos required a slightly longer exposure than the ones on the right (where there was more light), so I gave them a few extra seconds.

A major difficulty arises when the area to be corrected straddles two photographs, as it did here. Whenever possible, try to make problematic areas fall in the center of a single photograph.

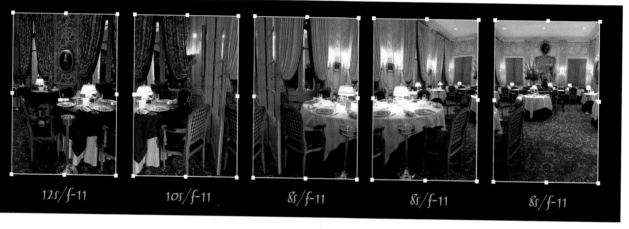

12s/f-11 10s/f-11 8s/f-11 8s/f-11 8s/f-11

You must set white balance manually so consecutive images will have the same color balance. The restaurant's two dining rooms were getting light from three different sources, so using automatic white balance mode would have been a disaster. I like my interior pictures a bit warm, so I always choose a color temperature slightly above the ambient one—in this case 3600 K.

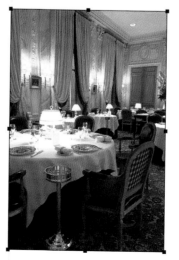

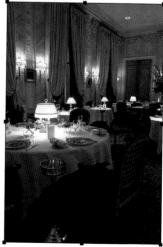

My final task was to photograph the table in the right foreground, whose center was slightly over-exposed by the lamps. In a photo, a large over-exposed area looks wrong, but it's good to retain a few hot spots; they give the picture energy. So my plan was just to shrink the area of over-exposure a little. I shot the table area twice, at very different exposures, without moving the camera. I first shot it normally, then under-exposed it by a stop and a half. (Beyond three f-stops the subterfuge becomes too obvious.)

Stage 3

Correcting over-exposures

As you can see, the center of the right-hand table, which straddles a pair of photographs, is too bright. So I took two sets of photographs: the first was exposed normally, like the rest of the series, and the second was under-exposed by almost two f-stops.

Don't under-expose the second photograph too much. If you do, the final result won't look realistic.

Using Photoshop and its layer masks, I now began the preliminary work of superimposing the under-exposed photograph on top of the normally exposed one to produce a picture that I could insert in the panoramic series.

I opened the first set of two images—the first correctly exposed, the second under-exposed. I selected the second one (Ctrl-A) and copied it (Ctrl-C).

I then selected the first picture and placed the copy on top of it (Ctrl-V). The Layers palette now showed the under-exposed picture on top of my background picture. Until I changed the opacity of this upper layer, the background remained completely hidden.

Stage 4

Superimposing two pictures

To superimpose the two pictures in Photoshop, I used the layer masks linked to the layers. The upper image (the one I just placed) covers the background only where the layer mask is white. My task: create a layer mask on the upper layer (called "Under-exposed") and paint it black wherever I didn't want any under-exposure—everywhere except the center of the table.

This is too delicate an operation for the Brush tool, so I used the under-exposed image as a mask.

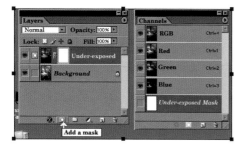

To create a layer mask on the upper layer, I clicked the "Add a mask" icon at the bottom of the Layers palette.

I brought up only this mask—totally white at this point — by unclicking the eyes next to the Red, Green, and Blue channels in the Channels palette. The channel for the mask itself must be left selected. (A quick way to do this: simply click the mask in the Layers palette while pressing the Alt key.)

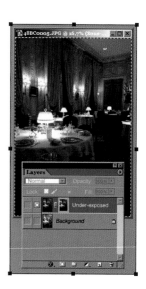

The mask, which is white by default and thus transparent, appeared onscreen. I pasted the image onto it (Ctrl-V), creating a single grayscale layer.

At this stage I could see the over-exposed areas in white, and all the others in levels of gray. This was perfect, because the outlines of the mask matched the outlines of my photographs exactly. I had managed to paint my mask with just two mouse clicks!

To finish this mask, I boosted its contrast and removed the gray from the darkest areas. Using Image→Adjustments→Curves, I moved the black threshold to the right and the white threshold to the left, eliminating the mask's midrange gray tones. To make the transitions less apparent, I then applied a 5-pixel Gaussian Blur (Filter→Blur→Gaussian Blur), and brought back the full color image by clicking its eye. The over-exposure was now considerably reduced.

To create a layer mask on the upper layer, I clicked the "Add a mask" icon at the bottom of the Layers palette.

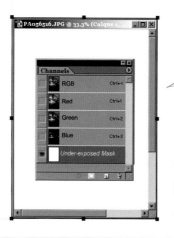

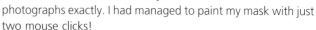

On the Channels palette, unclick the eyes next to all the channels except the layer mask's.

The mask is finally ready.

Finally, I flattened the picture I had just created and saved it as a new photo, to be assembled with the other photos in the series.

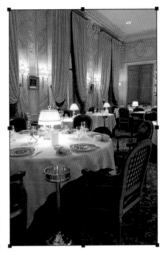

I now had to do the same thing with the second picture. This time, though, I used one of Photoshop's handy keyboard shortcuts. Once I placed the under-exposed image on top of the final picture, created a layer mask, and put the grayscale image on it, I again had to apply the Curves tool, using the same settings as the previous picture. But this time, I simply clicked Ctrl-Alt-M to retrieve the earlier curves settings. The two layer masks were therefore absolutely identical.

By clicking the eye to the left of the Under–exposed layer, I could easily check the effect of the superimposition and the quality of the layer mask on my assembly.

Stage 5

The assembly

Before launching ImageAssembler I made sure that the pictures were all the same size in pixels. Their format wasn't important since the program can assemble pictures in JPEG, TIFF, BMP, PICT, and other formats at the same time.

In ImageAssembler, images are assembled in two stages. First you launch the Lens Wizard, which needs at least two contiguous pictures from the panorama so it can calculate the parameters of the shot: camera angle, focal length, optical distortion, etc. Open a blank stitching project and pull the pictures into it, place a series of flags at the same places in two adjacent photos, and run a trial stitch by clicking a button on the toolbar. ImageAssembler calculates the parameters; you'll save these parameters and use them later when you stitch all the pictures together.

I opened the five pictures of the series and arranged them in order from left to right, including the two photos that I had earlier corrected in Photoshop. You can place the flags automatically or manually. I've had great success in placing them by hand, so I took the manual route. I then selected the Lens Wizard parameter file that had just been calculated, chose the projection type (in this case, spherical), and started the stitch.

In the completed assembly, the perspective was corrected: the straight vertical lines no longer converged. ImageAssembler's sophisticated algorithms do this by subtly warping the pictures, as if they'd been projected onto a sphere. Save the image in the desired format (JPEG, TIFF, and soon, PSD).

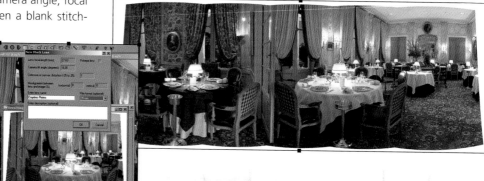

Note that the rotation axis of the camera was apparently perfectly horizontal, since the assembled photographs aren't tilted to one side.

For landscape photographs with areas of sky, I chose an Image Blending value of 50–60% in ImageAssembler and unchecked the Adjust Colors option.

Retouching

Final retouching is made easier if your monitor is correctly calibrated and Photoshop is set for proper color management (Edit → Color Settings).

To finish, I used the adjustment layer to check the various levels of the final image—brightness, color balance, and such—as I would for any photograph.

If the pictures were properly shot to begin with, most of your retouching work is done. But check for any assembly artifacts that may have appeared in the overlap area. You'll need to use Photoshop's Clone Stamp tool to gradually eliminate these artifacts the old-fashioned way. Future versions of ImageAssembler will let you paint directly on the layer masks linked to each photograph since the resulting assembled image can be saved in Photoshop's PSD format, maintaining all the layers you've created.

The layer masks associated with adjustment layers can be very handy when you only need to make corrections to a specific area.

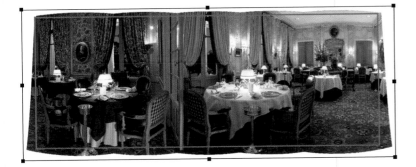

It's hard to tell from the resulting panorama that it was created by assembly, or shot with modest means and fairly quickly. ■

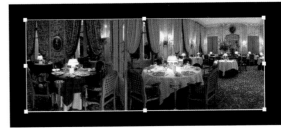

All that's left to do now is to trim the uneven edges of the photograph with Photoshop's Crop tool.

25

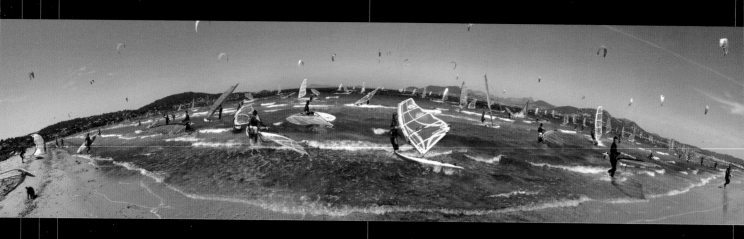

The problem with rotating panoramic cameras is that they always pan across a scene the same way, warping perspective the same way from one shot to the next. If you want to introduce variations, you have to create your panoramas by assembly; high-end software will make the montage easier. At Almanarre Beach, however, parts of the scene — the waves and the reflections on the water, for example — were changing too quickly. Stitching the photographs together automatically would have been impossible. So I did the job by hand to preserve the quality of textures and the integrity of shapes, right down to their smallest details.

Studio 03

ALBERT **LEMOINE**

Hardware used
- Nikon FM2 film camera
- 35mm lens
- PC with Althon 1800+ processor and 1.5 GB RAM
- 19- and 22-in. Mitsubishi monitors

Software used
- Photoshop 7

Frenzy at Almanarre Beach

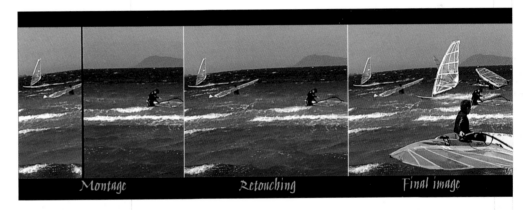

Montage Retouching Final image

Bending the horizon of a panoramic landscape is an easy way to make it look interesting. Without it, this scene of Almanarre Beach on the French Riviera's Giens Peninsula would look pretty dull. There wasn't a cloud in the sky, and the light was even, unrelieved by any backlighting. You couldn't even see the shoreline because I had to stand in the water to get close to my subject. The only major compositional element was the horizon, under the straight line of the sky. Unless I curved the horizon, it would be hard to make it a compelling part of the picture!

Curving space produces a distinctive "fisheye" look, but without the drawbacks. The pictures that make up this panorama were shot with a 35mm lens, so they don't show too much distortion or oversized foregrounds. I wanted to focus on my real subjects—the windsurfers on the water and the "flying surfers" (the paragliders) in the air—and create a visual balance by devoting large areas to the sails and the kites.

All landscapes **are imaginary,**

all panoramic landscapes even more so.

Stage 1

Imagining the panorama

Looking at this picture, a panoramic photographer might be perplexed. What camera did I use, and how? Swing-lens or rotating cameras produce similar-looking images, but in my panorama the median line is strangely tilted, and the curved horizon defies all symmetry.

A large panoramic landscape is hard to compose because you can't take it in with a single glance. You choose the starting point and let your camera do its job—and the camera winds up defining the picture. Personally, I prefer letting my imagination impose its point of view. And I enjoy defying the generally accepted principles of composition that state that a horizon should be straight and that a tilted photograph is obviously a mistake. My panoramas match my vision, not any technical demands.

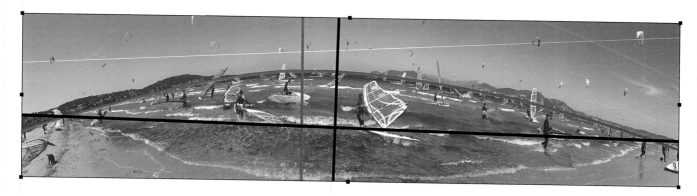

My camera is an ordinary Nikon, and the technique I use to create panoramas isn't limited by the laws of optics or geometry; it only obeys my aesthetic demands. You can produce all sorts of effects without expensive equipment, and the techniques are simple and easy to apply. Look at the picture below, for example, where the ocean seems to sit on the sand like an immense dome. I created it from seven pictures. In positioning the ocean, my only guiding principle was to keep the shoreline straight.

Photography can be a wonderful instrument
in the service of the imagination.

This freedom of expression lets me render my most fantastic imaginations realistically, sometimes with surprising results. Even when a montage seems impossible, if you have a clear vision, you will always find ways to express it.

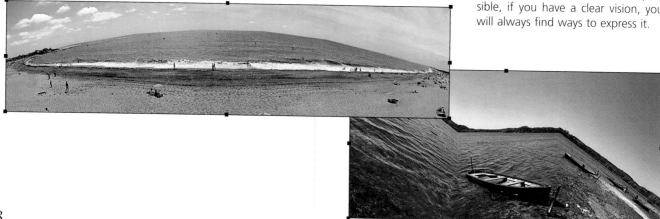

Stage 2

Scouting

It was 11 o'clock on an April morning; the light was sharp and perfect. As the wind came up, the windsurfers all rushed into the water despite the cold. I took a position near the shore so I could capture the scene up close with a 35mm lens. Unfortunately, the windsurfers raced by me and gathered in the distance.

I needed to take at least five shots of each picture in order to have enough sails and kites to fill the scene when the panorama was later assembled.

With a little luck, I would find 8 photos among those 40 pictures (5 shots x 8 views) that would line up well enough to connect the waves in the foreground. It would make the later retouching work that much easier.

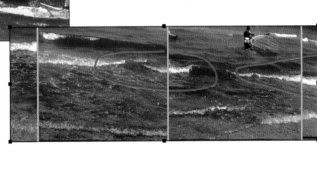

Assembling a panorama with such changeable and unpredictable subject matter might seem overly ambitious. But if the scene had been static, and therefore easy to handle, the photograph would have been disappointing. With the tools and techniques at my disposal, everything is possible. The key is to start with a precise vision of the final image, because that will determine how you go about taking the pictures. Later, assembling the montage will be fast, and it won't need to be changed.

If I had taken only a single shot for each of the eight photographs that comprise the panorama, the foreground would have been empty.

Stage 3

Creating the curve

If you work with a 35mm camera, it's best to shoot your pictures freehand—as a matter of speed and flexibility—even for a panorama. When the light is changing and clouds are flying by, you have to grab your shots quickly; otherwise the pictures will be impossible to assemble. And if your subjects are moving or your shooting position requires some gymnastics, using a tripod just isn't practical.

For a panorama such as this one, making a preliminary sketch will help you visualize the curve. When you lay the sketch out and relate it to the grid in the viewfinder, you can then accurately mark the series of junction points between pictures.

In order to plan your shots, it's helpful to have a grid in your viewfinder.

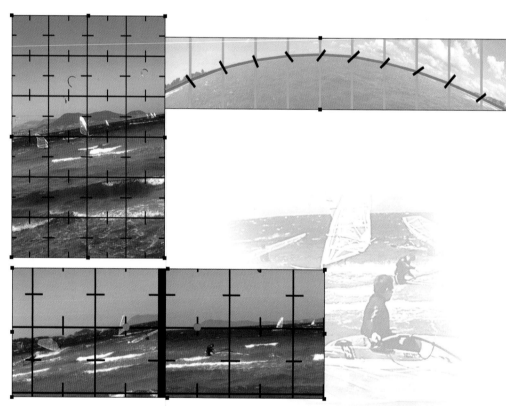

When looking for a place to join two photos, have them meet in the middle of the picture, not at the edges, so the images have a lot of overlap. This will make the later retouching work with layer masks easier.

In a seascape where the horizon line is very powerful, curving it rearranges all the space around it, making the horizon the dominant element in the composition. If the curve is perfectly rendered, it will appear that much more meaningful, and the panorama will start to resemble a beautiful blueprint.

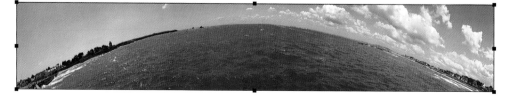

In *Almanarre*, I wanted to give the composition a feeling of movement, as if an imaginary wind were blowing across the picture, so I drew my curve to suggest that. I decided to make it asymmetrical and tilted slightly to the right, to give the image more rhythm and dynamism.

Little mistakes in composition aren't a real problem.

They can be eliminated during assembly, or reinterpreted, as was the case here.

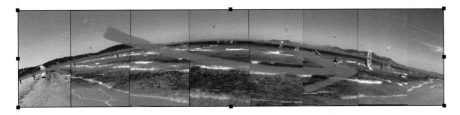

Less symmetry = more rhythm

Since the panorama would consist of eight pictures, the center of the curve should theoretically fall between the fourth and fifth photograph. To create the asymmetry I was after, I moved the center to the left, to the fourth photograph. In that picture, the horizon would be perfectly "horizontal" [sic!]. It would also be my "anchor" photograph, the shot from which I would angle the others down.

I now had to overlay this imaginary curve onto the panorama's actual horizon. After checking the location of the anchor photograph in my viewfinder, I shot that picture. I then continued to the right, came back to the center, and finished by shooting the three pictures on the left.

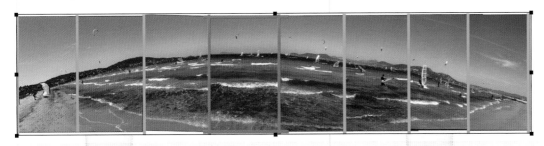

All the photographs were taken with identical exposure settings—again, to simplify the montage and retouching.

In order to produce a smooth curve, I tilted the horizon by exactly the same angle from one shot to the next. As a result, the curve ended lower on the right since there was one extra picture on the right-hand side.

Later, while assembling the montage, I felt that the imbalance created by this extra picture was excessive. So I subtly narrowed each of the four pictures on the right. The background no longer quite corresponded to reality, but so what?

Stage 4

The components of the image

Many things were missing from the eight background photographs and would be brought in from other pictures. But even that wouldn't be enough; I had to re-shoot some pictures more than once to catch windsurfers in distinctive and interesting positions. If you must do this, don't change your shooting position. Later, you can roughly select parts of other pictures with the Lasso and bring them in as layers with some of their own background. If your shooting position hasn't moved, those backgrounds will be similar and much easier to blend in.

I did the same thing with the waves. Importing them whole would spare me the trouble of fixing other waves that had been chopped off.

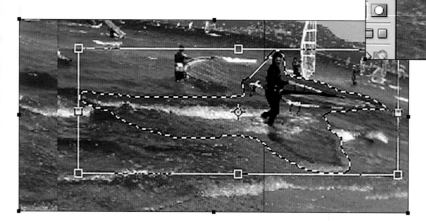

These pictures were taken with the same exposure settings as the earlier ones, and, of course, during the same shooting session. Therefore, I had to hurry. If the wind had died, the waves wouldn't have looked the same. Light changes quickly. The eye doesn't perceive it, but two photographs taken an hour apart look very different. It's possible to play with these variations, but I didn't want to—my goal here was a panorama that was as realistic as possible.

To simplify retouching the seams, I also took a few pictures of large areas of water and sand in the foreground. Later, I could put them directly over problematic areas.

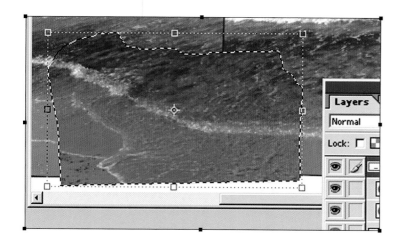

S t a g e 5

Positioning the layers

Having scanned the photos from my shoot, I chose the eight pictures that would comprise the background, and imported them in layers. When I lined them up, I was happy to see that they matched almost perfectly, top to bottom. If a shot had been too high or slightly tilted, I could have pulled it down or rotated it, but that would mean a transformation, degrading the quality of the image still more. As you modify a picture, the degradation adds up and the differences, compared to unchanged areas, are visible on a large printout. So I tried not to make too many manipulations.

Warning! I was careful to click on the layer mask thumbnail so I would be affecting only the mask. The border wasn't cut, only masked. Later, to refine the merger, I very gradually erased the mask to bring out parts of the border.

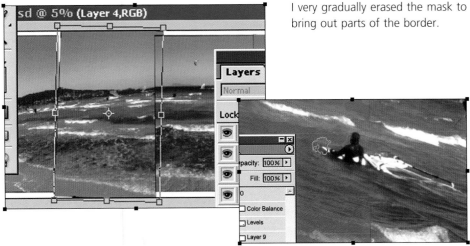

The panorama now looked unbalanced; it was too long on the right, and instead of a curve, I had a series of facets. Hmmm — what if I drew the sea as if it were an enormous diamond? Well . . . maybe some other time.

For starters, the four shots on the right had to be trimmed, so I squeezed them together by increasing their overlap. I added an empty layer mask to each layer. Now I had to choose the right place to cut between the layers. Using the Rectangular Marquee, I isolated the excess edge of one of the layers. I filled the selection with black, which caused the layer to disappear in that area, allowing the layer underneath to show through. (You can't see this in the illustration because the mask appears in red.)

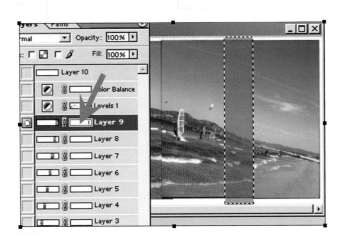

S t a g e 6

Retouching tools

*The settings for the selection and retouching tools
vary with the resolution. Here they apply to pictures
taken from film scanned at about 3000 dpi.*

I now had to deal with the facetted curve, which I would smooth by flattening its angles. The Liquify command is ideal when you want to work quickly, but it degrades the image too much, so I used another technique. Using the Lasso with a 1.3-pixel feather, I drew a triangle that included part of the horizon line. I converted my selection into a layer (Ctrl-J), brought up the Transform bounding box (Ctrl-T), and moved its rotation axis to the point of the triangle. Luckily, there happened to be a small sail right there, and it hid the new angle produced when I pivoted this portion of the horizon downward.

Once these small triangular layers were merged, I corrected the texture on their outlines so they blended perfectly. The Patch tool is excellent for this. I also used the Clone Stamp tool, but I had to fiddle with the point's hardness and master diameter settings from the Brush dropdown that appears on Photoshop's options toolbar. (A 100% hardness setting leaves marks; at 0%, the texture becomes blurry; and 50% isn't a good compromise if you want to preserve the grainy quality of the photo.) Ideally, the setting should be hard, but not leave any marks. You have to create it, test it, and refine it with the Brush Tip Shape settings in the Brush Presets palette.

I repeated this same operation on the adjacent shot on the right so the two segments would match. Enough of the ugly angle had disappeared to give the illusion of a real curve.

The panorama assembly was finished; now I had to clean up the seams between the pictures and populate the scene. Oddly enough, joining the images of the sky was the most troublesome. There weren't any clouds, so I didn't have any varied textures to hide the retouching flaws. Photoshop's Healing Brush and Patch tools would have been very effective, but they require that the layers be merged.

Since I wasn't going to flatten the image until the last moment, I decided to use the layer masks. This works just as well as the Healing Brush and Patch tools, and might even be faster. I reshaped their edges by alternating between the Eraser and the Brush, using my personal wide-diameter presets. Even when the brightness difference between two layers was very slight, I did my best to adjust it.

I revealed the rest of the images by erasing relevant parts of the masks using the Eraser and the Brush tools at 100% opacity.

Having finished the corrections in the sky, I then turned to the sea, and was glad I had overlapped the shots so generously. As a result, sails and waves often looked like they'd been chopped off by the line between two layers created by the mask. But the rest of the underlying images were there.

Stage 7

The heart of the matter

As I worked my way down the picture, the appearance of the sea changed more and more, and the disparities between overlapping pictures increased. Some waves now extended under the mask; others ended at the actual edge of the layer. There were several possible ways to deal with this. If the snippets or segments of wave weren't essential to the overall composition, I eliminated them with the Patch tool or left them where they were, hidden by the mask.

In addition to the waves, the pattern of the sea itself was very changeable. I evened out the variations of light and texture on the water, but loosely and over larger areas. I would wait until I had flattened the image to fix any remaining mistakes with the Patch tool.

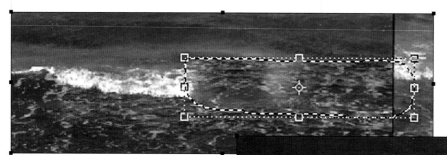

Otherwise, I found similar-looking waves in other pictures. I roughly selected them with the Lasso using a 2-pixel feather and brought them in, either whole or in part, depending on what needed to be recreated.

If an area was just too hard to fix, I didn't bother. I could always disguise it by placing a sail or a person there later.

As I reworked all this material, I was inevitably moving away from reality. But although photography is malleable, it tends to retain its believability. There are aberrations in my panorama, but you don't notice them—and I'm not talking about optical distortion or the unusual mob of windsurfers. Look at the wave in the foreground that matches the horizon, for example. Notice how it somehow stretches the entire length of the beach?

S t a g e 8

Reality or imagination?

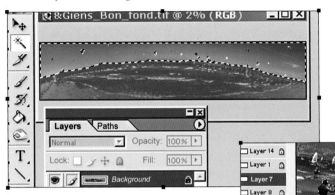

Once I finished the retouching, I merged the eight layers so I could make overall adjustments. In general, I like to adjust the color and brightness of the sky independently of the rest of the picture. First, I selected the sky and saved the selection with a 0-pixel feather, then shrank it by 3 pixels and applied a 2-pixel feather.

I applied the Filter→Noise→Dust & Scratches filter with a radius of 3 pixels and varied the threshold from 11 to 20, depending on how much I wanted to soften the grain in the sky. (Cloud texture requires a threshold of about 13.)

I then retrieved the 0-pixel sky selection, inverted it, shrank it by 2 pixels, and gave it a 3-pixel feather. Turning to the sea, I applied the Unsharp Mask filter with an Amount ranging between 90 and 130, a radius of 0.8 pixels for fine grain, and as much as 4 pixels when I wanted to emphasize some-

thing. The threshold was set at 4 levels to keep artifacts from appearing in the shadow areas.

My panorama was starting to look pretty good. I made the final color and brightness adjustments, working on the sky and the sea separately. Then I shrank their selections by 2 pixels with a 2-pixel feather, so that borders wouldn't appear along the line between air and water.

The beach still seemed strangely empty, however, which didn't correspond to reality. I solved the problem by importing and carefully positioning more windsurfers and paragliders from my other pictures. If the figures looked too small where I had placed them, I moved them further away so they fit the perspective.

I feel that a picture is a success when its credibility is tinged with a slight feeling of strangeness.

After resting for a few hours, I plan to revisit the panorama with a more neutral eye to further refine colors and brightness which always vary the longer I sit in front of the monitor. ∎

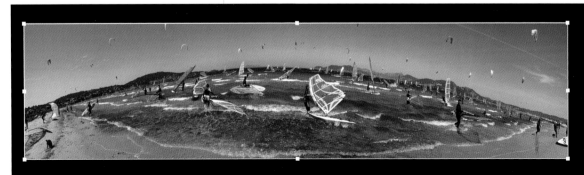

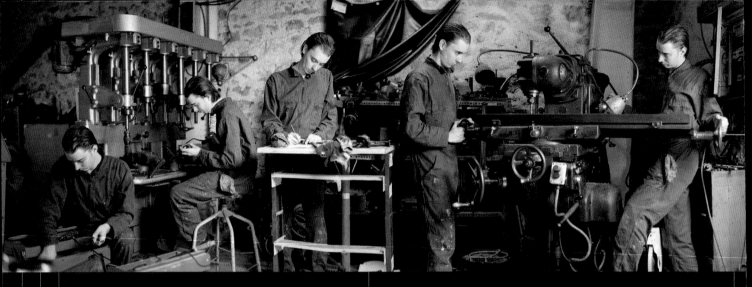

This image was part of a project I did for an exhibit arranged by the Seine-Saint-Denis regional council on the theme of "Memories of the Industrial Age." It couldn't be just "a beautiful picture." It also had to embody a concept, a thought addressed to both the author and to the viewer. Thanks to digital retouching with Photoshop, everything is possible.

For this particular setting, I created multiple images of myself as a way of raising the question of identity in a world dominated by mass production, and how it has led us to prefer identical copies instead of unique objects — even when it comes to humans! I used a common workplace scene — in this case, a workshop — where each identical character is engrossed in his own inner world.

S t u d i o 04

CHRISTOPHE **NOËL**

Hardware used
- Sinar 4 x 5 view camera
- Balloon light, without flash
- 4 x 5 Polaroid and Portra 160NC sheet film
- 500 MHz Power Mac G4 with 512 MB RAM
- Wacom graphic tablet
- Imacon virtual drum scanner

Software used
- Photoshop 7

The Workshop

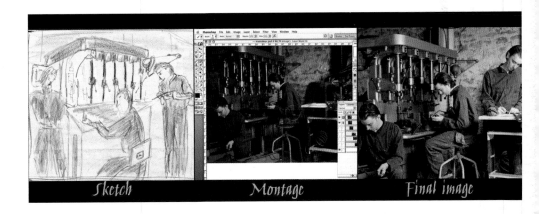

Sketch *Montage* *Final image*

Montage and digital retouching are an important part of my work, but only as an adjunct. I try to avoid letting them become the main subject, like one of those movies where special effects start to dominate the story.

For *The Workshop,* I wanted to produce a realistic pictorial rendering that, if cleverly done, might fool the viewer. It called for a warm, enclosed space, and a format like that of the great frescoes of the 18th century. I looked through many books, was appalled by the photographs of working children by Lewis Hine (1874–1940), talked with workers, and generally followed people who have worked with their hands in this modern era. To this I added my own meager experience as a mechanic; it was long out of date, but it affected the picture. Then I pulled on my coveralls and went to work with gusto.

My photographs are little works of fiction. They aren't designed to *recreate reality or a version of reality.*

Stage 1

Location scouting and Polaroids

The workshop I chose to take my pictures in was too narrow to allow me to step back very far. The shooting was done on a Sunday, when nobody was working, and took about one day. Since I decided to put myself in the picture, I had to figure out where to place each character, both on the ground and in space. I made a sketch during my visit so I could imagine each person's position and posture.

Having **thought** through the project and made my sketch, *it was finally time to turn theory into practice!*

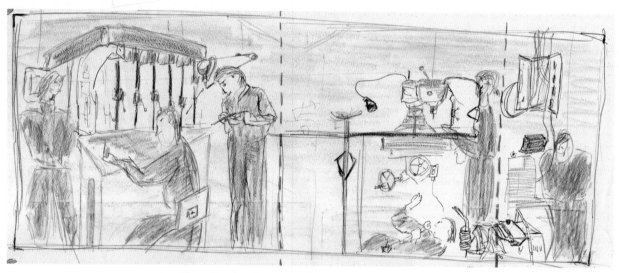

Making the sketch was a pleasurable part of the shoot, since it let me imagine the scene's eventual composition.

To push the pictorial look as far as I could, I used a 4 x 5 Sinar camera and ambient light—in this case, the neon light fixtures—which I augmented by an unusual balloon light. This is a tungsten unit that spreads its yellowish light in all directions so you can't tell where it's coming from. I tried to arrange the characters in a curve from left to right, to lead the eye through the whole picture. I had originally planned to use six characters, but it was soon obvious that this was one too many. Also, I didn't want viewers to get the idea that this was a montage of a single person accomplishing several tasks one after another, but instead a team of workers—a kind of group portrait.

Stage 1

My aim was to have each character maintain a certain independence, playing his own role while remaining a link in the workshop chain— autonomous but inseparable from the others.

Since I was dealing with a series of self-portraits, I obviously had to do everything, being both in front of and behind the lens. Only when it was time to trip the shutter did someone else (my girlfriend) step in.

I started by taking a series of test shots on 4 x 5-in. ISO 100 Polaroid sheet film to get an idea of how the light filled the room and see how the composition looked.

1st Polaroid

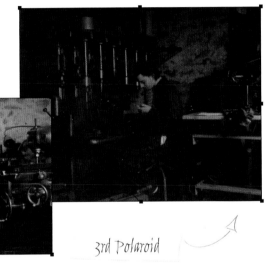

3rd Polaroid

This also gave me a sense of the work to be done in Photoshop—how much retouching the lighting and perspective it would require. I could see that most of the work on the perspective would be needed between Polaroids 2 and 3. I noticed the lighting was too harsh on the right side of Polaroid 2 (another drawback of a shallow shooting space). The left side of that picture, on the other hand, didn't need much light since I would be using Polaroid 3 there.

Two things would prove to be very important in composing the picture: the toolbox on the left in the first picture and the blue boxes in the center shot.

The red toolbox would catch the viewer's eye first, and would be a good visual point of entry to the scene. The blue boxes, a second element of bright color, would let the viewer pause to consider the whole scene—or at least that's what I hoped.

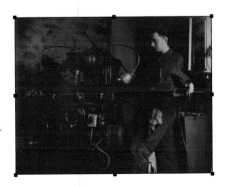

2nd Polaroid

Stage 2

First attempt

Once the framing and lighting were settled, I took a first series of pictures with the Sinar view camera, following the sketch I had made. Since self-portraits were involved, I needed to see how the scene worked in "real time."

Given the lighting arrangement, this was the only way for me to see what was happening in the picture so the final output would be exactly what I wanted. As with shooting a movie, you must play a scene over and over again until you get it right, so you have a wide range of performances to choose from. This indirectly affects retouching, because the more "right" a scene looks, the more it draws viewers in, and the more they're willing to overlook minor retouching errors.

I decided to give myself as much time as I needed to accomplish what I wanted.

I did a quick, rough montage in Photoshop using the shots I had just taken. I overlaid the layers with layer masks without bothering to outline them very carefully with the Airbrush tool, in order to get an idea of the work that lay ahead.

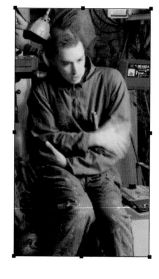

I immediately realized that the fourth character from the left was all wrong: he gave the scene a "jokey" look, and wasn't believable. The fifth character also attracted too much attention. Though bathed in warm light, he appeared to be cold, which created a contradictory impression; that wouldn't do.

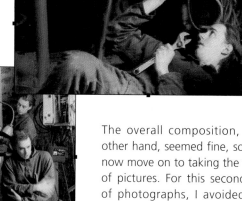

The overall composition, on the other hand, seemed fine, so I could now move on to taking the final set of pictures. For this second round of photographs, I avoided overly demonstrative positions, and kept the expression on my face fairly neutral.

I took six photographs. When I overlaid the pictures in my mind, I got the feeling
that a lot of things — maybe too many — were happening around the table in the center.
To balance the scene, one of the workers might have to go, either the one writing
or the one next to the blue boxes.

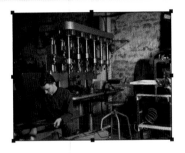

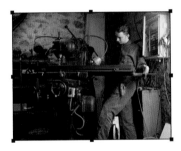

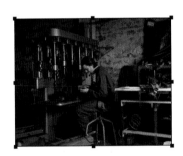

I could see right away that
it would be hard to mesh the
perspectives between
these two pictures.
This area would require most
of the retouching.

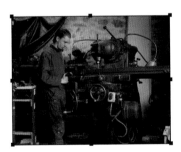

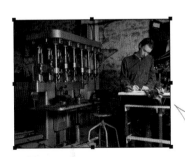

I felt that one of these
two characters might
have to be eliminated.

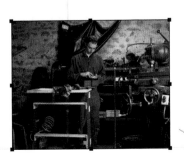

S t a g e 3

Ensemble

The hardest part was over! Well, sort of.... I shot the photographs on Portra 160NC Kodak color negative film, which gives you more control over lighting than sheet film. I digitized the photos on an Imacon virtual drum scanner, to preserve the sharpness.

Since the final image would be about seven feet wide, I could afford to create big enlargements while retaining perfect definition.

The final size of an image determines the way you work. Retouching a 4 x 6-in. picture isn't the same as retouching one that is seven feet long.

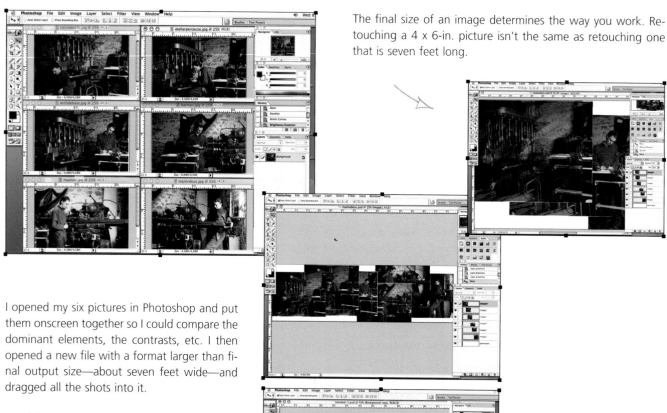

I opened my six pictures in Photoshop and put them onscreen together so I could compare the dominant elements, the contrasts, etc. I then opened a new file with a format larger than final output size—about seven feet wide—and dragged all the shots into it.

I could now start superimposing the pictures. I worked on the characters one at a time, starting from the left and flattening the layers as I went, to save memory. I saved each stage in separate files in case I wanted to come back and rework them later. For starters, I moved the first picture on top of the second at 50% opacity and used the arrow keys to align them, right down to the pixel.

Stage 4

Merging

Once the superimposition was done, I returned my layers to 100% opacity. In the layer menu, I then created a layer mask on the first image, in the uppermost layer (Layer→Add Layer Mask→Reveal All). With the Airbrush at 100% opacity, I started to bring out the character underneath by brushing only on his area.

The technique of using layer masks is totally safe as long as the layers aren't merged or flattened, since you aren't destroying any of the pictures. You can bring out or hide any part of a layer you like.

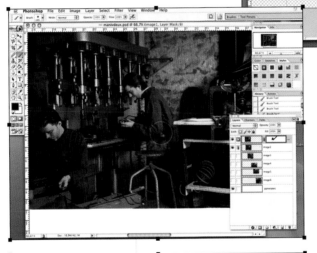

Thanks to the milling machine in the right part of the image, I was able to cheat in straightening the perspective. I only kept a small part of the machine: the horizontal table, which I tilted upward slightly and retouched with the Clone Stamp tool to strengthen the image. I then uncovered the rest of the panorama, including the picture of the last character.

As you can see, I had trouble with the center of the image. The edge of the layer mask gives you an idea of the struggle I waged. The problems were due to the original shot, objects being superimposed on each other, warped perspective, and visually distracting elements.

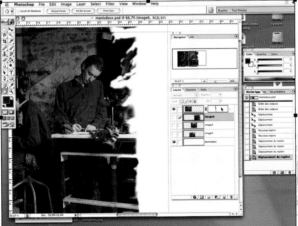

Stage 5

Manipulations

The black line of the milling machine table leads the viewer's eye along a horizontal line, which is reinforced by the picture's panoramic format. This all helps distract the viewer from minor faults in the perspective of the picture. If you look at the table in the center of the picture, you notice it has a slight bend. Do you suppose it was built that way?

The last character was the closest to the light source, and was too brightly lit. The fuse box at the upper right of the picture was too bright as well, so I outlined it with the Magnetic Lasso and adjusted its brightness and contrast.

For retouching and selections, I use a 6-inch high-resolution Wacom graphic tablet and stylus, so I can easily and precisely adjust pressure.

The more the image is manipulated, the more *believable it seems, which is kind of disturbing when you think about it.*

I then merged all these images and adjusted the intensity and light on the last character. Finally, I added a Curves adjustment layer to reduce the green tones and shift toward a warmer, more enclosed feel.

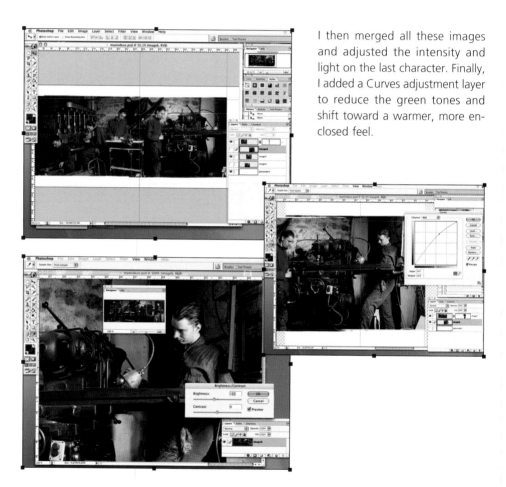

I tried not to change the original colors too much. Using curves is very tempting, but they can have a strong impact on your final picture. You have to go slow, and keep your final goal in mind.

Stage 6

The end of the day

The Workshop was finished; all I had to do was harmonize the overall image. Compared to my original concept, I had removed one character, who crowded the center of the scene.

At last, the picture was done. There are probably easier ways to create a panorama like this, but its workmanlike look is part of its charm. Now that I look at it, I'm sorry I didn't pull down the black plastic sheet hanging on the wall in the background. Oh well, there's always something you want to change or do over! ■

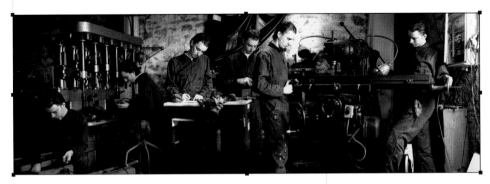

I want to thank Jean Chesneau for his patience and kindness in lending me his workshop and allowing me to take photographs there.

The right side of the picture still seemed a little too green, so I did a few selective color balance corrections (Image➤Adjustments ➤Color Balance). But I worked cautiously and carefully; the eye adapts quickly and it's very easy to overcorrect.

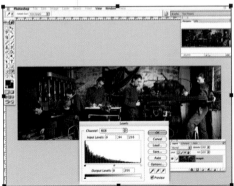

At times like this, it helps to ask someone who hasn't seen *the evolution of the montage and the lighting corrections for their opinion!*

This final stage called for examining the picture's levels (Image➤Adjustments➤Levels) and making the appropriate corrections. A levels adjustment lets you see the current tonal range for each color channel (red, green, and blue) as well as for the composite image (all channels together).

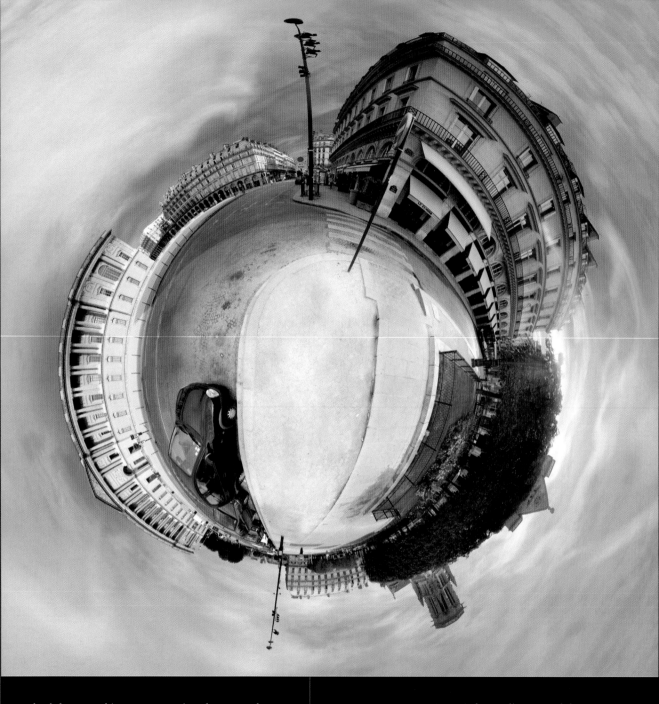

I had been making panoramic photographs for several years — classic panoramas at first, then 360° panoramas in QuickTime VR — when one day I decided to twist one of my pictures into a circle, to see what it would look like.

By a complete fluke, I discovered how to create what I call "spherical" panoramas. Needless to say, the results far exceeded my expectations.

Studio 05

SACHA **POPOVIC**

Hardware used
- Olympus Stylus 300 digital camera
- PC with 2GHz Pentium 4 processor and 1 GB RAM

Urban Sphere

Software used
- Photoshop 7
- Stitcher 3.1
- 3ds max 5

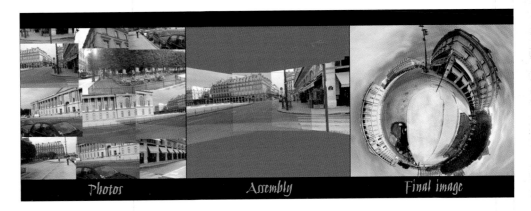

Photos Assembly Final image

This picture is part of a collection I am creating of spherical panoramic photographs of Paris. The aim of the project isn't to make a set of postcards of the city's monuments—extraordinary though some of them are—but to find locations where the spherical treatment would produce an original and aesthetic point of view.

The first questions everyone asks when I show them this collection are, "How did you do that?" and "Did you use a fisheye lens?" This chapter will show you how I did "that"—and without a fisheye lens.

One of the things I like best about a spherical **rendering is** *how it turns any scene into a small planet. Each neighborhood, intersection, park, etc., becomes an entity unto itself.*

S t a g e 1

The basic principle

Before considering questions of aesthetics and graphics, you first need the right equipment to shoot such a picture correctly.

You must operate as if you were creating a classic panorama, with this exception: you must cover all angles of view, meaning 360° horizontally and 180° vertically, as if you were in the center of a sphere. In fact, the stitching software will later map the pictures on the equivalent of a sphere.

Equipment

The tripod you mount your camera on is essential to shooting a panorama correctly. You need a panoramic head that can pivot 360° around the nodal point, on two axes. As far as I know, there are only two pan heads on the market specifically suited to this kind of photography: the Kaidan Quickpan III with spherical bracket, and the Manfrotto 303SPH. Personally, I use a custom-made pan head built by a handyman genius—my father.

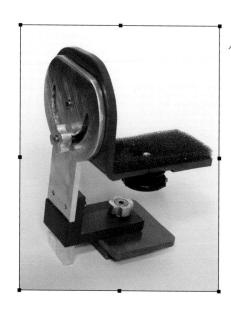

Using a digital camera makes the job a lot easier. For one thing, it means you don't have to scan some 60 photographs for each panorama, which is a distinct savings in time and money. Nor do you have to make all the photos exactly the same size in pixels so that a program like Stitcher will accept them. Given the number of photographs needed, you can get very satisfactory quality with a midrange camera (3 megapixels) for pictures up to about 11 x 17 in. in size.

Stage 2

Taking the pictures

I began this series of photographs of Paris by making a lot of tests. Most were purely technical: I was trying to get a perfect image, without any visible seams. But once I had mastered the technique, I realized I had overlooked something vital. A beautiful photograph—whether panoramic or not—is born of one third technique and two-thirds creativity.

In the beginning, framing the photographs gave me the most problems, but the real challenge was the overall composition. Unlike taking a picture in a studio, you can't just move buildings around. And unlike a landscape photograph, you can't simply shoot what's in front of you since you also have to pay attention to what's behind you. The secret—the real key to this kind of photography—is choosing the best place to put your tripod. In practice, a large fountain 20 yards from the camera will be tiny in the final image. Likewise, a bridge 30 yards away will almost be invisible. You have to consider anything beyond a ten-yard perimeter as essentially insignificant, although it will have some effect on the overall composition.

The main difficulty is accurately visualizing how the picture will turn out. Forget any guidelines you may have learned in "classic" photography, and don't rely on appearances, which are often misleading. For example, don't set up within five yards of a streetlight or a tree: it will wind up filling a quarter of the panorama. In general, once you've positioned the tripod, you should see nothing but sky when you point your camera up.

The sun is a precious ally, but it can play some nasty tricks on you. It's constantly moving, so all the shadows are moving as well. To avoid problems with seams, which take a long time to retouch, I always start by shooting the horizon line first, then I very quickly shoot the lower row of pictures. Clouds are less of a problem, even if they're moving.

I only moved a dozen yards between taking these two *photographs of the Passy Viaduct, but the results are radically different.*

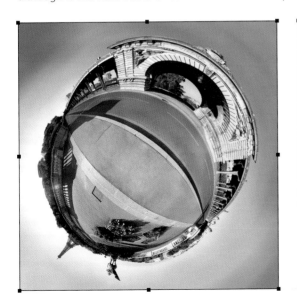
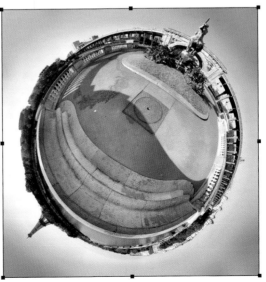

Stage 3

Assembling the pictures

Once you've shot all the pictures, the assembly work can begin. After trying various software programs, I decided that Real-Viz's Stitcher was by far the simplest and most professional, and it produced the most beautiful results.

Loading the photographs

After loading the pictures in Stitcher, drag one of the photographs from the horizon row into the Stitching Window. You can then set the program's parameters for the focal length used when you took the pictures. Depending on your camera, it may take several tries to get optimal results. For example, even though my digital camera indicates a focal length equivalent to 35mm, I get better results if I enter 38.1mm in Stitcher's Properties window.

Now drag picture number 2 onto number 1, and overlap the parts they have in common. If you have to rotate a picture so it matches the adjacent one correctly, pivot it around a specific point, such as the corner of a window.

Once the second photograph is properly in place, stitch it to the first photo by pressing the Enter key. The Stitching Window will center on the second photograph, which is now placed in the middle of the workspace. Follow the same steps with the other pictures until the horizon row is complete and has looped back on itself. If you can align the last photograph of the series with the first one on your first try, congratulations—you're a master! Otherwise, select the final photograph and press the Close Panorama button. When the screen turns blue, align the last photograph with the first one.

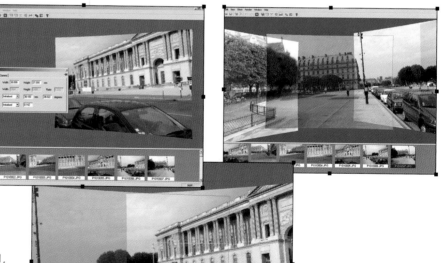

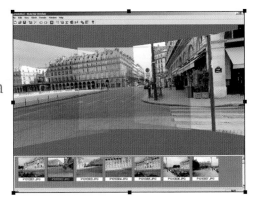

Completing the panorama

When the panorama of the horizon-row pictures is finished, use Stitch→Adjust All Images to determine the series' optical distortion and focal length.

You can then run an initial verification rendering by pressing Ctrl-R (Command-R on the Mac). This opens the Render dialog box. Choose Cylindrical for the format type and an output width of 3000 pixels. Then click Preview to make sure there is no distortion.

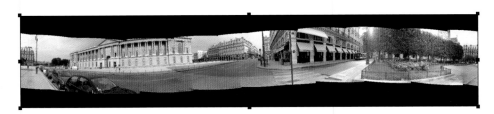

Next, load all the pictures in the rows above and below the horizon line, one after the other. It's a good idea to do an overall adjustment from time to time, again using the Adjust All Images command. When all the pictures are in place, the effect is a bit like being inside a ball.

Before generating the final render, the colors must be equalized. This is something that Stitcher does very easily, and in spectacular fashion. Go to Render→Equalize All Images. Pick an image on the horizon row that will serve as a center around which the panorama will be calculated, and press Enter. (Write down the name of your chosen photo; if you have to run another rendering and you don't start from the same image, the result won't be the same.) Then, output the render in TIF format (Ctrl-R), with Spherical as the export type. The output resolution will depend on the power of your computer; a width of 10,000 pixels produces very handsome results.

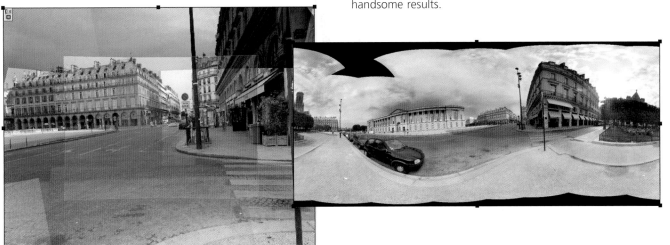

Stage 4

"Spherizing" the panorama

There are several ways to wrap your panorama around a sphere. How you do it will depend on your software and your computer's processing power.

The simplest method is to use Photoshop. Open the image and go to Image→Rotate Canvas→180°. Enlarge the canvas so that you get a square document, and align the bottom of the panorama along the top edge of the canvas. Then apply the Polar Coordinates filter (Filter→Distort→Polar Coordinates), choosing the Rectangular to Polar option.

> The size of the final image is greatly limited by the computer's horsepower, which I find very frustrating. This is especially true if you only have Photoshop; it's really hard to produce a big enough file (6 x 6 in. at 300 dpi).

As an alternative to Photoshop's filter you can use the Flexify filter from Flaming Pear, which produces better results but is more complicated to use.

Personally, I use 3ds max, which has a lot of calculating power and lets me produce 20 x 20-in. files at 300 dpi, which is nothing to sneeze at. But any 3D software will do the trick. All you have to do is project the image produced by Stitcher onto a half sphere or a flat surface (using the deformation in polar coordinates) and launch the recalculation.

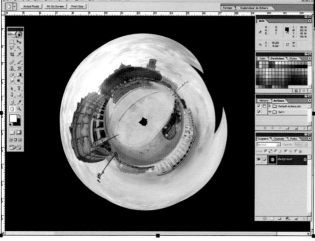

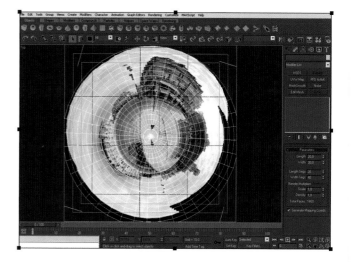

The Polar Coordinates filter produces a decent result, but the image is now much smaller.

Fill the four corners with sky.

Add texture.

Retouch the center and add to the image.

Check the sky color balance and add texture where necessary.

Stage 5

Retouching with Photoshop

By now you should have a pretty good idea of what the final image will look like, as well the work that remains. First, you must deal with the four corners: use the Clone Stamp tool to fill them with sky. You don't have to be too meticulous here. It's no problem if a few stamp impressions can be seen; we'll soften them later.

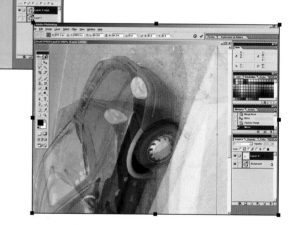

The center of the image will require more time because it's the part that is the most apparent. Also, it often needs a lot of retouching that isn't always obvious. With the Liquify tool, start by straightening the shapes in the center, which were slightly stretched during spherization. Note that this stretching is only visible if the lower part has been chopped off. (For example, when you don't have enough photographs, which is the case here.)

This operation is hard to complete in a single pass. I always copy my picture onto three layers and straighten the shapes on each one of them as carefully as I can. I then choose the best parts—the areas of the various layers where my retouching was most successful—erase the rest, and flatten all the layers.

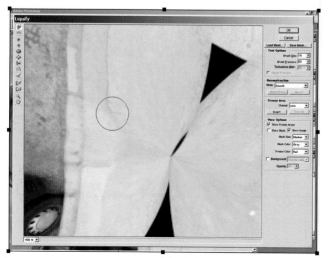

To fix other distorted elements in the picture, such as the front of the car, use one of the original photographs you shot. Just stick the picture on a new layer and distort it so that the part that you want to fix more or less overlays the one underneath in the montage—in this case, the car wheel. Once the picture is in place, move it with the Smudge tool until it matches the background perfectly.

As for the sand that is missing in the middle of the image, it's best to get the texture from an original photograph rather than using the Clone Stamp tool.

The center of a spherical panorama is always the trickiest and the most distorted. To make retouching it with Photoshop easier, I usually take three or four shots from different heights with the camera pointed toward the ground. Better to have too many pictures than not enough.

Stage

Retouching the sky

At this stage, the image is coming along nicely; in fact, it's almost finished. To make the sky a little more even and add any needed texture, try using the Clone Stamp or the Healing Brush judiciously. Or you can simply apply a different sky to the entire image in Multiply mode. Here, I used a sky that I created using Bryce, a 3D landscape creation program. But there's nothing to prevent you from taking a sky from some other panoramic photograph.

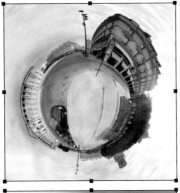

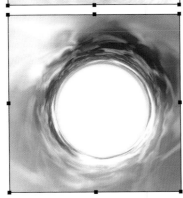

A little warmth

The image was now quite attractive, but it looked somewhat artificial. To remedy that, I made the sky's color a little warmer to better match the color of the buildings using a Hue/Saturation adjustment layer.

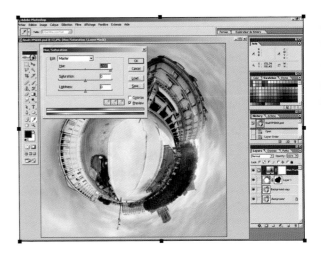

I put this reworked sky on a layer in Multiply mode at 70% and gave it a layer mask that excluded the entire landscape; that way, only the sky was affected.

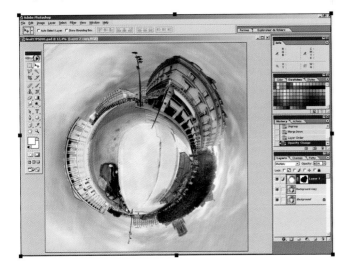

With the image finished, all that remains is to show it to people and watch their reactions. As you have seen, technique is very important in creating this kind of panorama. But don't forget that the main thing is to find an interesting point of view, so your picture will be both surprising and meaningful. If you don't pay attention to composition, you may fool people with one or two pictures, but not a whole collection. ■

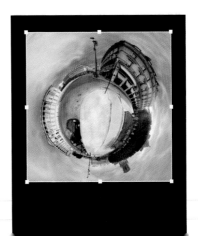

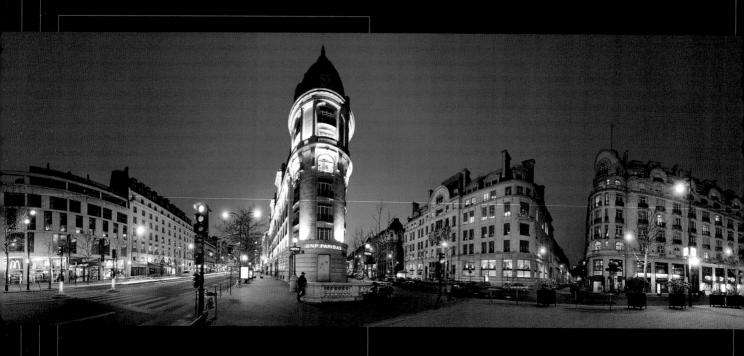

When taking photographs with regular cameras, I've often been frustrated by their narrow field of view. Since I didn't want to have to use a swing-lens camera like a Noblex, I turned to panoramic assembly techniques to create this picture, which is part of a series of photographs I took of Paris at dusk.

Studio 06

PEET **SIMARD**

Hardware used
- Canon EOS-1Ds digital camera
- 17–40mm zoom lens and 19mm wide-angle lens
- Manfrotto 303 panoramic head
- Gitzo Explorer tripod
- Power Mac G4 with 450 MHz dual processor

Software used
- iView MediaPro 2
- Stitcher 4.01
- Photoshop CS
- Debarrelizer Photoshop plug-in

On the Boulevards

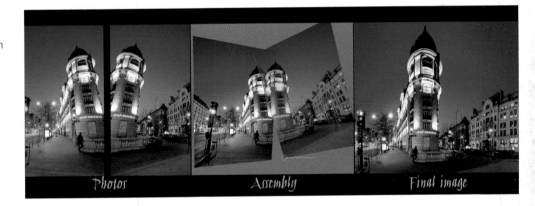

Photos Assembly Final image

I've always wanted to photograph this intersection of two of Paris's great Haussman-era boulevards, especially from a low angle and with a field of about 200°. But I couldn't do it, neither with a Hasselblad XPan (no perspective correction lens; field of view too narrow) nor a Sinar (no wide-angle lens wide enough). I tried and failed with a 15mm fisheye lens on my Canon 1Ds: I used the Imaging Factory's Debarrelizer plug-in to turn the resulting picture into a horizontal, but the edges were too stretched and the picture wasn't sharp enough to blow up. (The photograph had to be printed in very large format for an exhibition). To solve the problem, I turned to assembly techniques. RealViz's Stitcher program is excellent, because it can assemble low-angle pictures shot with a wide-angle lens while straightening perspectives and correcting optical distortion.

Paroramic assembly completes a landscape **photographer's panoply** *of shooting techniques, and does so without requiring awkward or costly equiment.*

Stage 1

Taking the pictures

I started by scouting the best location for my camera, deciding on the focal length, and choosing the hour when the light would be at its most magical. I settled on 20 minutes before total darkness in late March, right after the streetlights came on. I set up my tripod, adjusted the panoramic head so the horizontal rotation axis was level, clamped the camera on, set it in portrait mode, and framed the scene.

To take the photos, I tilted the camera about 20° upward. I left plenty of empty space above the building in the center of my scene, knowing that when Stitcher straightened the perspectives, it would chop the tops off the low-angle pictures in the center of the series. I set the focal length at 19mm to completely fill the 24 x 36mm frame.

I made sure that the ball head was set so the camera would rotate around the lens entry point. Using the click stops on the pan head's rotation ring, I overlapped the pictures by about 20%.

Settings for the shots:
- Exposure: 3 seconds at f-9.0, ISO 100
- White balance: tungsten
- Format: RAW with simultaneous small JPEGs

I then measured the light with a 1° spot meter. As often occurs in night photography, parts of the building facades were overexposed. In order to have a choice of material to work with, you can take one "normal" shot and a second one underexposed by about two f-stops. Later, you can put them on separate layers in Photoshop and use a layer mask to integrate the shot with the highlights with one that was properly exposed.

In this case, I didn't bother. The hot spots on the main building were fairly small, and they were surrounded by cornices and other details that would provide enough texture. Besides, night was falling and I didn't have the time.

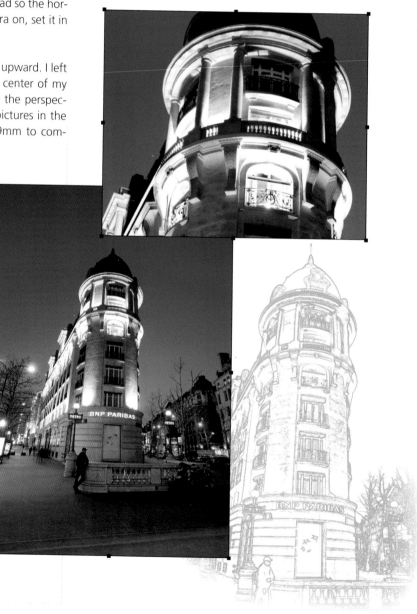

Stage 2

Preparing and loading the files

I loaded the source files into iView MediaPro, a media management program, to sort the photos. I had to shoot each picture several times, and often out of sequence, because whenever a car drove by, its headlights swept across the scene, ruining my shot.

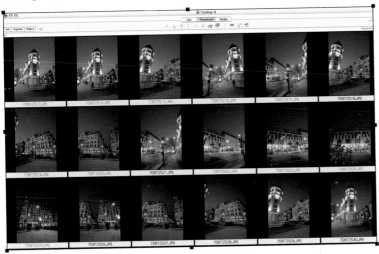

Once I had chosen a set of pictures, I copied the files, arranged them in montage order from left to right in a new folder, and renamed them so they would appear in the proper sequence for Stitcher.

To get a quick preview of the assembly, I started by working with the 8 MB JPEG pictures that my camera produces at the same time as the 32 MB RAW files. I saved them in TIFF format since I would probably have to modify them a few times. (JPEGs degrade after being saved repeatedly.)

In the photos at each end of the series, the sky looked much darker than in the middle shots. That's because the narrow

One of Stitcher's strong points is its ability to equalize *discrepancies in brightness and color between pictures.*

building in the center was due west of my shooting position, and I was taking pictures at 7:55 in the evening. It would be interesting to see how Stitcher managed to balance the gaps before I had to intervene with Photoshop.

I closed Photoshop to free up memory and then launched Stitcher, giving it 80% of available RAM—about 750 MB.

I then moved the images directly from iView into Stitcher, where they appeared in the Image Strip window. I started the assembly by dragging a picture of the central building into Stitcher's workspace.

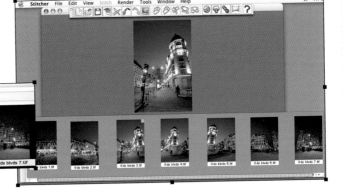

S t a g e 3

Calibration

I dragged the second image of the central building next to the first one and matched them as best I could, using the image rotation function (Display→Rotation).

Before I assembled these first two images (by clicking the Stitch icon), the program calculated focal length and corrected optical distortion for all the pictures in the project. This makes an assembly much easier when a short focal length has been used, and in this case, it was essential.

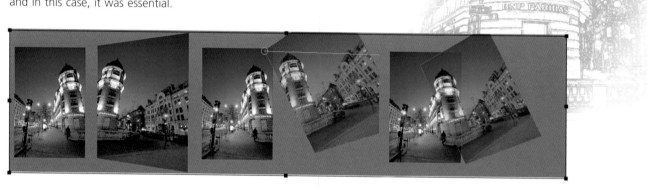

I then chose Tools→High Distortion→Calibrate, and noted the settings for this focal length with Tools→High Distortion→Register the Lens Parameters. You can reuse these settings any time you use your lens at that focal length, or when you need to redo the assembly.

Alignment

Straightening the horizon line is much easier if you do it at this stage than if you have a complete row of pictures. Just press the A key. Later, if some of the buildings are out of kilter, you can straighten them out with the Align the Panorama command.

Stitching

I assembled the rest of the photos the same way. To avoid having to rotate each picture as I added it, I applied the Tools→Go Back to Defined Horizon command (Command-H) before dragging the new picture into the workspace. The central photograph—the one that showed all of the main building—wasn't needed for the assembly, so I omitted it.

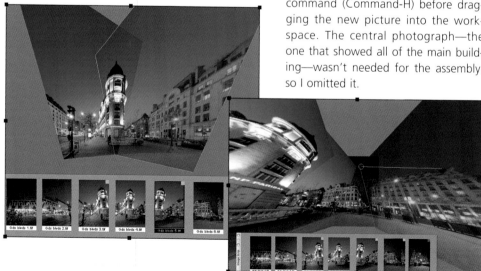

S t a g e 4

Retouching

Before proceeding further, I thought it might be useful to take a quick initial peek at the montage. In the Stitching Window, the program displays the assembly projected on the inside of a sphere. If the montage is wider than 120°—as was the case here—you can't get a complete planar view in the window.

Before rendering the assembly, **it's essential**
to generate a quick first draft.

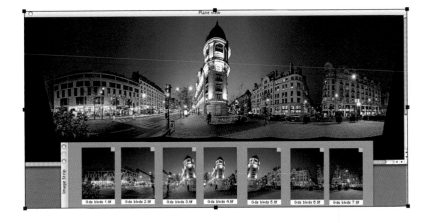

Draw a bounding box around the area you want to eliminate or retain, as the case may be.

Stitcher can output the render in Photoshop's PSD format with layers, so you can use Photoshop to fine tune your creation, working directly on the layer masks that Stitcher creates.

This first look revealed two problems. First, the traffic light was both red and green, because it changed between two of the stitched photos, so I used the Stencil tool to eliminate the green light. Second, there was a lot of color variation in the sky; to smooth this out, I raised the equalization coefficient to the maximum (Preferences➤Render➤Equalization➤1). To apply it, I selected Render➤Equalize All Images.

The Stencil tool

Stitcher's new Stencil tool acts on the layer masks of two overlapping images to eliminate elements that may have moved between the shots. You can also use it to erase "ghosts" when an assembly isn't perfectly aligned. Simply choose an image from the toolbar or the Stitching Window, select Tools➤Stencil, and a dialog box appears.

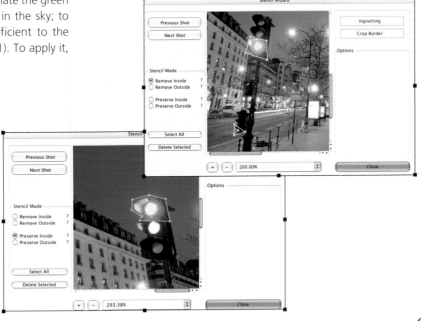

Stage 5

Rendering the picture

I created this first render in Stitcher at 100% of the screen height (760 pixels) in Photoshop format, using the Cylindrical projection. I tried the Spherical projection (see below) but it made the central building look too squat.

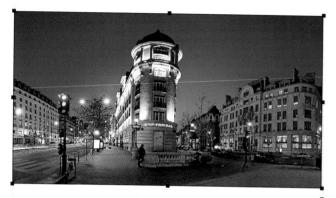

With the Cylindrical projection, the building was stretched vertically a bit, but I thought it looked more elegant. I could have gotten nice straight perspective lines if I had taken the photos with a perspective correction lens, but Stitcher can't assemble that kind of picture.

After going to Render→Set Render Area, I selected the render area and its size in pixels.

Because Stitcher couldn't equalize the images as they were, I had to open and modify them in Photoshop. But I first saved this version of my project.

With all the source images open in Photoshop, I selected the sky with the Magic Wand tool and modified its edges on an adjustment layer set in Luminosity mode so the color balance wouldn't be too uneven. I darkened the sky in the center images a bit and lightened it in others. I saved these images with their adjustment layers intact in another folder. The images were then flattened and again saved in the source folder.

Back in Stitcher, the program integrated these modified images back into the project. Once that was done, I equalized the colors (Menu→Toolbar→Equalize) for a smoother rendering.

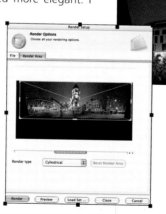

The sky is obviously very uneven, and you can see the seams between photos.

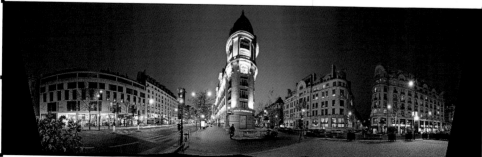

Stage 6

Eliminating "ghost" images

In Photoshop I looked at the pictures at 100% to see if there were blurry areas at the seams where two linked layers are masked. If there are, you can activate the appropriate layer mask that Stitcher created for the two overlapping layers and paint on it—in white or black—to erase the ghost image on the misaligned layer.

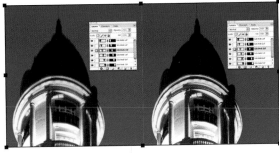
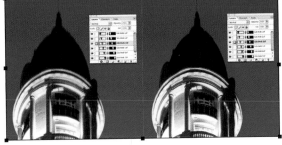

Adjusting density and color balance

In Photoshop, I then created a new layer in Overlay mode with an opacity of 100% and filled it with 50% gray. (Select Edit ➤Fill from the Use dropdown, select 50% Gray, and select Normal from the Mode dropdown).

Painting on this layer with black subtly increases density; painting with white increases brightness. Together, they let me blur some uneven areas in the sky and re-emphasize the buildings.

I applied a Curves adjustment layer to remove a few red spots and add some contrast. I also toned down the brightness of the red traffic light by selecting it and using Images➤Adjustments➤Hue/Saturation.

The Debarrelizer plug-in

I first saved one version of the panorama with all its layers, then flattened them and applied the Debarrelizer plug-in to reduce the bulge that is typical with this kind of assembly. The operation clips the edge of the pictures a little, which is why I gave myself plenty of margin at both ends.

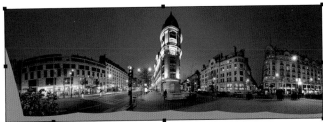

When I re-cropped the picture to match my original vision, the photograph was finally finished. The end result was a file assembled from six images that measured 3969 x 10713 pixels (122 MB at 8 bits), or 16.5 by 44.5 in. (42 x 113 cm) at 240 dpi without interpolation. ▪

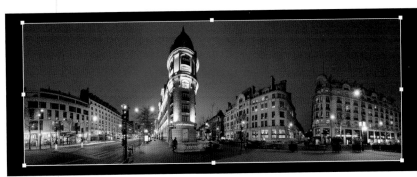

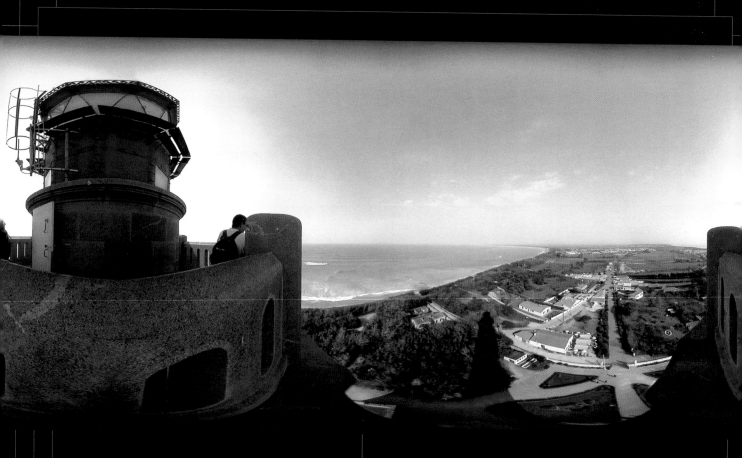

When creating panoramic photos and interactive
QuickTime movies, I generally take lots of
photographs, using a sturdy tripod with a
specialized panoramic head. But every so often,
I like to shoot freehand with a minimum of gear,
to get pictures that I otherwise couldn't. This
simple way of working certainly doesn't replace
multi-row panoramic assemblies, especially in
terms of precision, but it has the advantage
of being very fast, and can be used in many
different circumstances.

studio 07

LAURENT **THION**

Hardware used
- Nikon Coolpix 5000 digital camera
- FC-E8 fisheye converter lens
- 400 MHz Power Mac G4 with 512 MB RAM
- Wacom graphic tablet
- 22-in. LaCie monitor

Software used
- Photoshop 7
- Panotools plug-in
- BBedit Lite
- CubicConverter 2.0.5

The Phare des Baleines Lighthouse

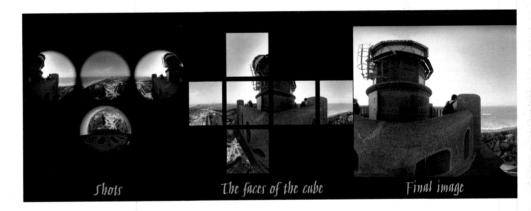

Shots The faces of the cube Final image

Believe it or not, this complete spherical projection was made from only four photographs, taken with an ordinary handheld digital camera. But while the technique requires only minimal gear, it does demand experience—and some serious training. For me, the toughest part of the project was climbing the 257 steps to the top of the Phare des Baleines Lighthouse ("Lighthouse of the Whales") that stands at the western tip of the Île de Ré, on France's Atlantic coast. If nothing else, creating a complete panorama with no more than a handheld camera is very attractive. My goal: to turn the image I capture into a 3D interactive panorama that you can view on a web page with the QuickTime player.

This sort of picture **is especially well suited** *to on-screen viewing.*

S t a g e 1

Taking the pictures

My plan was to take three photographs, turning my camera 120° between each picture. The rotation axis is located at the lens entry point, in the thickness of the front element of the viewing system.

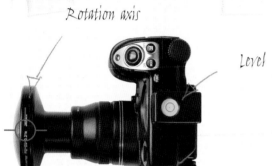

Rotation axis

Level

Lens entry point

Especially when taking the first picture, it's very important that the camera be perfectly straight and level on all three axes. That first shot will become the reference point for the assembly, and will anchor the other two pictures. In this case, I stretched my arms out into space while carefully watching the camera's built-in level.

View A

I then turned the camera 120° to the right while trying to keep it at the same height and as horizontal as possible, and took the next shot (view B). I then returned to my initial position, turned 120° to the left and took the third shot the same way (view C).

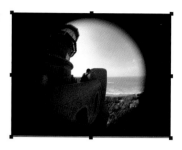

View C

I also photographed downward (view D), so I'd have something to fill the nadir. A downward shot isn't absolutely necessary if the ground surface is homogenous (gravel or grass, for example). Likewise, you don't need an upward shot if the zenith is uniform.

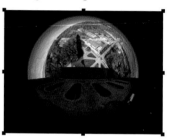

View D

It's a good idea to train yourself to hold the camera horizontally using the level, remember to turn around the lens entry point, and accurately estimate the 120° intervals between shots. It's largely a matter of practice.

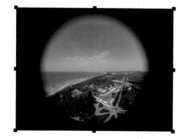

View B

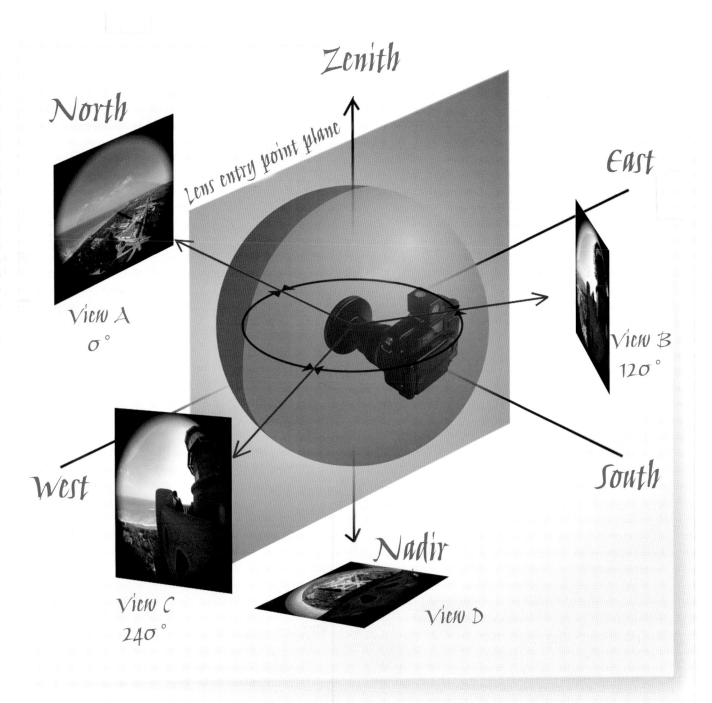

Zenith

North

Lens entry point plane

East

View A
0°

View B
120°

West

View C
240°

Nadir

View D

South

Stage 2

Preparing the pictures

In order for the Panotools filters to work properly, the raw source images must be cropped, and the dimensions of the different pictures must be exactly the same.

If a centering error occurs, cancel the operation and crop the images by hand using Photoshop's Rectangular Marquee tool. Enter the values as measured in the tool's options by opening the Style dropdown menu (below Photoshop's menu bar) and selecting Fixed Size.

The pixel is the unit of measurement here, because pixels will later be used to enter the photographs' dimensions into a BBEdit script.

Warning: You must save these images in TIF and JPEG format, both in RGB. (The Panotools plug-in supports 8- and 16-bit images, but not CMYK separations.) You'll use the TIF files for the later montage assembly.

I opened all the pictures in Photoshop and measured the circular image's diameter using the Measure tool and reading the figures in the Info palette. I rounded off the diameter to 1780 pixels.

Measuring the useable diameter

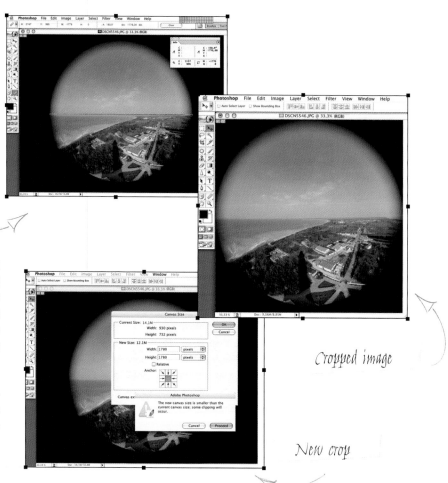

Cropped image

New crop

In the Image➤Canvas Size dialog box, I cropped the pictures using the 1780 pixel value I obtained earlier. If the camera's CCD sensor is correctly centered, the cropped picture should just brush the edge of the circle. I cropped the other pictures in the same manner.

When Photoshop's warning message appeared ("The new canvas size is smaller than the current canvas size; some clipping will occur"), I clicked the Proceed button.

S t a g e 3

Preparing the script

The script is a text document created in BBEdit that will auto-mate the transformations you'll apply to the pictures. You can name it whatever you like; in this case, I called it *scriptphare.txt*. (Don't delete the .txt suffix, even when working on a Mac.)

```
p  w3600

i  w1800  h1800  f2  r0  p0  y60   v185  a0  b0.1  c0
i  w1800  h1800  f2  r0  p0  y180  v=0  a=0  b=0  c=0
i  w1800  h1800  f2  r0  p0  y300  v=0  a=0  b=0  c=0

v  v0  b0    r1  y1  p1    r2  y2  p2
```

This script must be edited to include the size of the source pic-tures. On the first line, which corresponds to the output width of the panorama in pixels, enter the diameter of the circle, times two (1780 x 2 = 3560). In the next three lines—there is one for each picture—enter the measured diameter (1780) af-ter each *w* and *h*. Don't change any of the rest of the code, and leave the last line as it is.

```
p  w3560

i  w1780  h1780  f2  r0  p0  y60   v185  a0  b0.1  c0
i  w1780  h1780  f2  r0  p0  y180  v=0  a=0  b=0  c=0
i  w1780  h1780  f2  r0  p0  y300  v=0  a=0  b=0  c=0

v  v0  b0    r1  y1  p1    r2  y2  p2
```

To measure the reference points I use an HTML page composed of frames and JavaScript code that lets me directly choose pairs of points. You can also get the coordinates of each point in Photoshop. If they are se-lected correctly, four pairs of points are enough for any two images.

This produces the following reference point coordinates:

Between a and b

```
c  n0  N1  x1293  y1490  X505  Y1510
c  n0  N1  x1385  y1169  X273  Y1215
c  n0  N1  x1380  y983   X191  Y1018
c  n0  N1  x1294  y937   X104  Y970
```

Between b and c

```
c  n1  N2  x1183  y264   X499  Y230
c  n1  N2  x1278  y209   X598  Y278
c  n1  N2  x1554  y462   X510  Y556
c  n1  N2  x1454  y918   X237  Y926
```

Between c and a

```
c  n2  N0  x1447  y1216  X361  Y1201
c  n2  N0  x1624  y1198  X525  Y1133
c  n2  N0  x1537  y1348  X534  Y1268
c  n2  N0  x1244  y1539  X523  Y1534
```

At this point, open the *scriptphare.txt* script in your text editor and paste the code into the script document below the exist-ing lines in blue. Save the *scriptphare.txt* script and close it.

```
p  w3500

i  w1780  h1780  f2  r0  p0  y60   v185  a0
b0.1  c0
i  w1780  h1780  f2  r0  p0  y180  v=0  a=0
b=0  c=0
i  w1780  h1780  f2  r0  p0  y300  v=0  a=0
b=0  c=0

v  v0  b0    r1  y1  p1    r2  y2  p2

c  n0  N1  x1293  y1490  X505  Y1510
c  n0  N1  x1385  y1169  X273  Y1215
c  n0  N1  x1380  y983   X191  Y1018
c  n0  N1  x1294  y937   X104  Y970
c  n1  N2  x1183  y264   X499  Y230
c  n1  N2  x1278  y209   X598  Y278
c  n1  N2  x1554  y462   X510  Y556
c  n1  N2  x1454  y918   X237  Y926
c  n2  N0  x1447  y1216  X361  Y1201
c  n2  N0  x1624  y1198  X525  Y1133
c  n2  N0  x1537  y1348  X534  Y1268
c  n2  N0  x1244  y1539  X523  Y1534
```

Stage 4

Assembling the pictures

To finish adapting the script for the pictures, open the "view A" shot (which you saved earlier from camera to computer as, say, *a.tif*) in Photoshop and select Filter→Panotools→Adjust. In the Adjust Options dialog box, check both the Use Script and Run Position Optimizer radio buttons.

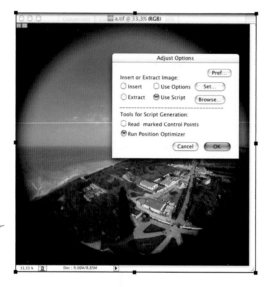

Capture 1

Click the Browse button, locate the *scriptphare.txt* script, and click OK. Wait a moment, then reopen the script with your text editor to confirm that the new lines of code have indeed been generated.

To apply this script to the pictures, select Filter→Panotools →Adjust in Photoshop (where *a.tif* is still open). In the Adjust Options dialog, check the Insert and Use Script radio buttons.

Capture 2

In Panotools, click the Pref button and check the "(b) Create New Image File" box. In the Set menu, specify the destination of the image to be created, and name it in the Save As field. The default name is *ptools_result*, but you can give it a different name. In this case, I chose *phare*. To complete the settings, go to the More menu and choose the interpolation option that best suits your needs and your computer's processing power. Click OK and a progress bar will appear.

> The four Panotools interpolations options are Polynomial, Spline 16px, Spline 36px, and Sinc. If you're using a slow computer, run the fastest (least processing-intensive) calculation option to get a quick idea of the result, then go back and pick the option that gives you the best output.

When this first calculation is finished, close the *a.tif* picture without saving it. Open the "view B" picture (*b.tif*) and apply the Panotools filter as noted above. (A shortcut: press Command-F.) Wait for this second calculation to finish, close *b.tif* without saving it, and repeat the process with the next image, *c.tif*. When this third and final calculation is done, open the resulting image (*phare*) in Photoshop.

Stage 5

Overall retouching

How much retouching the picture that Panotools has assembled will need depends on how carefully the initial photos were taken. In this case, the middle looks too dark and saturated, and the seams are still visible.

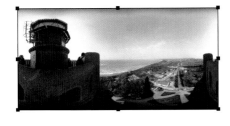

When you're satisfied with the result, flatten the image. This makes it easier to retouch any seams—such as the vertical bars in the sky—and to refine contrast and color balance corrections over the entire panorama, using adjustment layers and their layer masks.

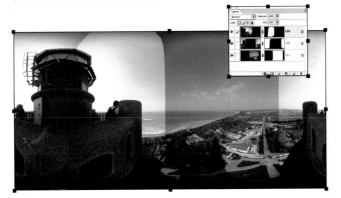

Before

The image has layer masks, so it's easy to use Photoshop's Brush tool to make different parts of a layer appear and disappear.

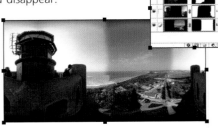

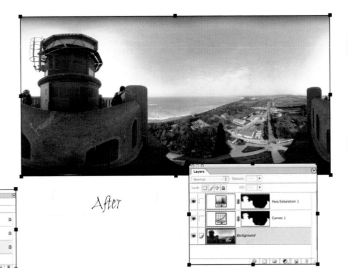

After

Here I applied two Curves and Hue/Saturation adjustments to lighten the lower part of the picture. Each adjustment layer had a mask, so the upper part of the landscape wasn't affected.

It's also often necessary to correct contrast or exposure differences between pictures. The key is using adjustment layers on the layer masks to unify the whole panorama.

Finally, save the panorama as a TIF file. You'll notice that retouching the extreme upper and lower parts of the picture is especially tricky when you get close to the edge of the frame. Don't bother spending too much time on them at this stage; we will deal with them later.

S t a g e 6

Retouching the zenith and the nadir

Among other things, CubicConverter lets you take a projection created by Panotools and apply it to the faces of a cube, which are easier to retouch. The program is quite intuitive to use. Drag the re-touched picture into the conversion window, select the Conversion tab, and in the Convert to dropdown menu, se-lect Cube Face Images and click the Convert button. After clicking on the Cube Faces tab, choose the top face of the cube on the left and drag the image into the folder on the desktop.

CubicConverter is a *very* **handy program that** *can convert panoramic files into a variety of formats.*

Selecting the face

Dragging the folder

Back in CubicConverter, choose the bot-tom face of the cube and drag the image into the work folder. While you're at it, do the same for all of the other faces of the cube, even if they don't need any retouch-ing. You'll get six TIF files named in this for-mat: *xx_f.tif, xx_r.tif, xx_b.tif, xx_l.tif, xx_r.tif, xx_d.tif, xx_u.tif.*

The sky in the picture was relatively uni-form, so the zenith shot can be retouched with just Photoshop tools. That wasn't the case for the nadir, however. For that, we are going to need the extra picture I took.

Preparing the "view D" image

Open the *d.tif* image in Photoshop and crop it to the same square format as in Stage 2; it's important to give it an or-thoscopic shape before pasting it inside the cube.

As is often the case with the Panotools plug-in, the image must be correctly cropped before you apply the filter, which takes format and scaling into account. Otherwise you can get a completely erro-neous result.

In Photoshop, use the Clone Stamp and Patch tools to retouch the center of the picture, then re-save the picture under the same name.

Original picture

Retouched picture

In the Filter→Panotools→Remap Options menu, check the Fisheye Hor and Normal options and enter the values 180 and 0 in the Hfov and Vfov fields, respectively. Then click the Pref button and choose "(a) Display Cropped/Framed Image." Click OK to accept these preference settings, and close the filter window by again clicking OK.

When the alignment looks right, save the transformation by pressing Enter. Raise the layer's opacity to 100% and add a layer mask by clicking the appropriate icon at the bottom of the Layers palette.

> Clicking on the layer mask's Create a New Layer icon while pressing the Option key produces a black mask. Use the Brush tool to paint the black away from the areas you want to reveal.

You'll undoubtedly have to adjust the color of the resulting bottom face as you did the others. But it's essential to not change the face of the cube itself; otherwise it will look different from the other faces when displayed in QuickTime VR. When you are satisfied with the result, save the image without changing its name.

Orthoscopic version of view D, produced by calculation

Completed bottom face

We're now going to retouch the bottom face of the cube. Open the *d.tif* file in Photoshop and select the entire image (Command-A), then copy and paste it onto the other view. Apply an opacity of 50% to this new (automatically generated) layer and position the picture as best you can using Free Transform (Command-T).

Matching the pictures

Stage 7

Creating the QuickTime VR file

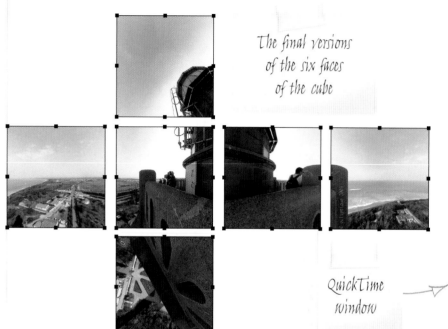

The final versions of the six faces of the cube

QuickTime window

Export the file (via Save As) and name it (in this case, *phare.mov*). You can then check the overall contrast, color balance, and sharpness using the QuickTime Reader, by simply double-clicking the file that was just generated.

In CubicConverter, drag the six cube faces you saved in TIF format into the conversion window. Click Convert To →Cubic QuickTime VR Movie.

Set the default parameters and save them. Click Change to select the degree of compression.

Final corrections

If the overall image seems a little too dark or light, or if the colors are too strong in certain areas, this can be remedied by correcting the six cube faces that comprise the QuickTime file.

Create backup copies of the six original faces, then open the group of pictures in Photoshop. You might want to use a Curves or Hue/Saturation adjustment on all the pictures, even if the change is practically invisible for some of them. But don't use an Auto Levels adjustment, because the result will vary from one picture to the next and make the faces of the cube look different. It's also wise to wait until this stage to do an overall adjustment of the image and to check the results in the QuickTime Reader by having Cubic-Converter compile a new file.

Stage 8

Integrating an HTML page

The *phare.mov* file must be linked to an HTML page so it can be viewed by a browser. You have to indicate the name of the QuickTime file to be viewed in these two lines between the <object> and <embed> tags.

```
<param name="src" value="phare.mov">
et <embed src="phare.mov".
```

> For most browsers to read the files correctly, you must use both the <object> and the <embed> tags, even though the movie title is included within the first tag. In running local tests remember to use the same values in each tag, even if the code works when only one of them is correct.

Image displayed in browser

In navigating a QuickTime VR movie, you click and drag to move the picture around, and zoom in and out by pressing Shift and Control, respectively. You can also control the extent of tilt, horizontal field, and maximum and minimum enlargement by setting the appropriate parameters in CubicConverter's Movie window.

Some of these adjustments can also be made after the fact directly in the HTML code using dedicated tags. A free tool, PAGEot (*www.qtbridge.com/pageot/pageot.html*), is extremely helpful in generating these optional tags. I also like Pleinpot (*www.qtbridge.com/pleinpot/pleinpot.html*), a great tool for adding a panorama to a web page.

The code below lets you display the QuickTime file in a size that is independent of the one generated by CubicConverter. This is due to the values entered after the width and height code, and the related action of the "tofit," which controls the image's scale.

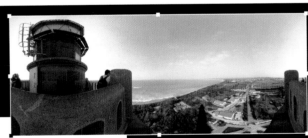

```
<html>
<head>
<title>Phare des Baleines</title>
<meta http-equiv="Content-Type" content="text/html; charset=iso-8859-1">
</head>
<body bgcolor="#222222">

<object classid="clsid:02BF25D5-8C17-4B23-BC80-D3488ABDDC6B" width="700"
height="500" codebase="http://www.apple.com/qtactivex/qtplugin.cab">
        <param name="src" value="phare.mov">
        <param name="controller" value="true">
        <param name="scale" value="tofit">

        <embed src="phare.mov" width="700" height="500" controller="true"
scale="tofit" type="video/quicktime"
pluginspage="http://www.apple.com/quicktime/download/">
        </embed>
</object>

</body>
</html>
```

That's it! This image is now available to the whole world on the Internet. The printed page can't really show the full range of this technique's interactive possibilities. To view this image (as well as others I have done), please visit my web site at *http://ecliptique.com/ phare.html.* ∎

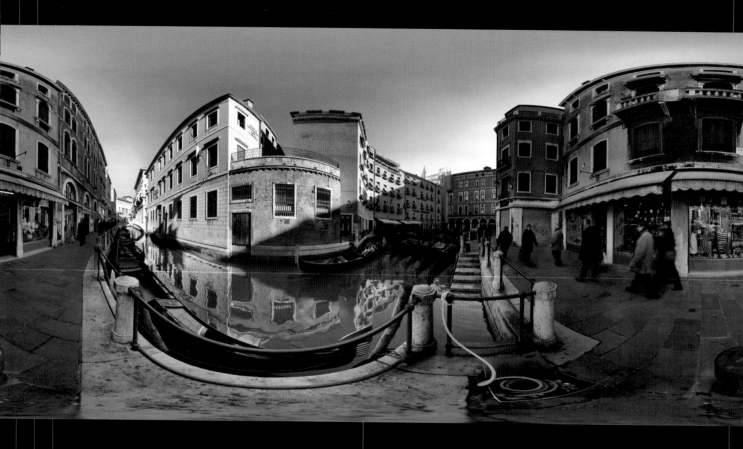

This photograph is part of a group of about one hundred panoramas of Venice I created in February 2004. It wasn't an assignment, but a personal project. My goal was to bring out the beauty, value, and richness of the special qualities of "La Serenissima," and to share my passion for this city with you!

Studio 08

GILLES **VIDAL**

Hardware used

- Canon EOS 300D digital camera
- Canon EF 17–40mm ultra wide zoom lens
- Manfrotto 055Pro tripod
- Agno's QuicklyQTcubic panoramic head
- Sony Vaio PC with 2.4GHz Pentium 4 processor and 1.25 GB RAM
- LG 17-in. LCD panel

Software used

- Stitcher 4
- Photoshop CS
- QuickTime 6.5

Venice: The Orseolo Basin

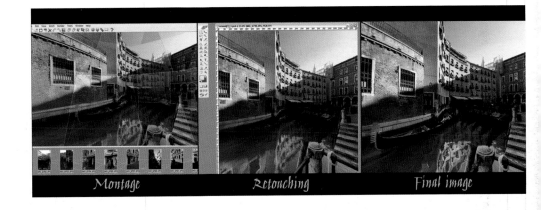

Montage Retouching Final image

I wanted this photograph to show a slice of life, the sort of thing you might see when strolling Venice's side streets. So I tried hard to faithfully capture the scene, limiting the montage's aberrations as much as I could. To create this 360° x 180° spherical panorama, I used RealViz's Stitcher 4, and did the post-production work in Photoshop CS.

The panorama was published on the Internet in a visualization window embedded in an HTML page using a QuickTime 6.5 player. It was also distributed on CD-ROM, again using QuickTime, but in a much more detailed version.

The believability of a panoramic montage **hinges**

on its smallest detail.

Stage 1

Method

The camera equipment I normally use is nothing special; it's closer to a dedicated amateur's gear than a professional photographer's. But when creating a spherical panoramic view, it's essential to use a reliable parallax head so the camera's lens entry point remains fixed. These days, four manufacturers make such heads: Manfrotto (303SPH), Kaidan (QuickPan III), Peace River (3Sixty), and Agno's (QuicklyQTcubic). I chose the Agno's, which isn't well known but is robust and accurate. It takes a while to get the hang of using it, but once mastered, the Agno's head is completely satisfactory.

The technique I used here was to shoot rows of photos, then overlap them to cover the entire sphere. The number of photographs required depends on the focal length used: the shorter the lens, the more shots you need.

The Canon EOS 300D's CCD sensor has a ratio of 1:6, and my 17mm lens is the equivalent of the 27.2mm lens found on a 35mm camera. Since Stitcher requires an overlap of about 30% between each photograph regardless of the focal length used, I would need to shoot a lot of pictures to complete the sphere—32, in fact.

I started by taking a series of 10 photographs at 90° from vertical (the camera was mounted in portrait mode), rotating the camera 36° after each shot. Then I took 10 more with the camera tilted down 45°, another 10 with the camera tilted up 45°, and finally one shot each of the zenith and the nadir.

Normally, the biggest difficulty is taking the nadir photograph—where the camera is looking straight down—since your tripod will be in the way and keep you from seeing the ground properly. The only reliable way around this is the "outstretched-arms" method: You take the photograph of the ground while holding the camera on the same axes and at the same height as it would be on a tripod. Theoretically, it's a quick and easy solution; in reality, it takes some practice to produce decent results.

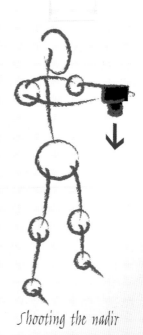

Shooting the nadir

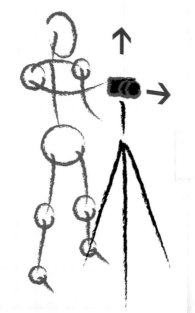

The Agno's head comes with a variety of click-stop rotation rings, which makes turning the camera to the correct angle every time very easy.

Stage 2

On location

Venice is a special city in more ways than one. I'm not talking about its beauty, canals, monuments, or other marvels, but its light. The luminous atmosphere is quite extraordinary, and it lets you play with colors and textures in surprising ways.

I prefer to take pictures in the morning, especially in Venice, before the streets are invaded by tourists. I took this photograph at about 9 a.m. on the Orseolo Basin, a well-known "gondola garage" near the Piazza San Marco.

On average, I need about 10 minutes to take this kind of picture, bearing in mind that the changing shadows and light make it a race against the clock. Under those circumstances, the automatic click stops on the Agno's head are very helpful.

Stitcher requires a minimum number of photographs, but there's nothing to stop you from taking more! I took 45 pictures from this shooting position so I'd have plenty of choices. They were all the same size—2048 x 3072 pixels—in the highest quality JPEG format.

After choosing the photos I wanted to use, I was ready to start the montage in Stitcher.

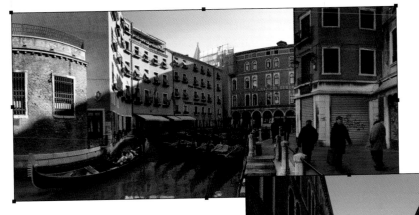

My shooting position allowed me to play with various contrasts: between light and shadow, straight lines and curves, volumes and perspectives, building façade materials (stucco, brick, and stone), and, of course, sky and water.

S t a g e 3

Stitching the horizontal row

Stitcher's interface is fairly basic: there's a toolbar below the main menu; most of the screen is filled by the Stitching Window, where the photographs are assembled; a picture gallery called the Image Strip runs along the bottom.

As with any program, it's often easier and faster to use keyboard shortcuts. Here are Stitcher's main (Windows) shortcuts: Alt-right-click to rotate the workspace; Shift-right-click to rotate a picture; Alt-click to move the workspace; Alt-Ctrl-click to zoom in and out.

When you launch Stitcher for the first time, set the various preferences (Edit → Preferences) for memory allocated to the program, thumbnail size, and display quality.

I proceeded to position the second photograph the same way, carefully placing it on top of the first, making the overlap area as clear as possible. I then launched Calibration (Tools → High Distortion → Calibrate), and Stitcher corrected the optical distortion for the entire group of pictures being placed.

As my photographs were imported (File → Load Images), they appeared as thumbnails in the Image Strip. To place the first photograph, I dragged it into the Stitching Window; the photo automatically appeared centered in the window, with a green border.

Main menu

Toolbar

Stitching window

Image strip

Stage 3

The first two pictures arranged in the Stitching Window are especially important. For Stitcher's calibration to work optimally, choose two photographs with as much information as possible, and a generous overlap.

I then positioned the rest of the pictures from the middle (horizontal) row, dragging them into the Stitching Window one after the other. Taking care to overlap them as much as possible, I assembled the photos either by using the contextual menu (by right-clicking the picture) or by pressing Enter.

By default, the Stitching Window will move the most recently stitched photo to the center.

I've gotten into the habit of regularly estimating the focal length used (Stitch→Adjust All Images). When Stitcher recalculates the focal length, it refreshes the workspace display to keep it as close to reality as possible.

When I reached the last picture in the horizontal row, I selected Stitch→Close Panorama. The appearance of the Stitching Window changed (the background turned blue) and I positioned the last photo on top of the first one. I confirmed the match by pressing Enter, and Stitcher quickly recalculated and refined all the pictures' focal lengths.

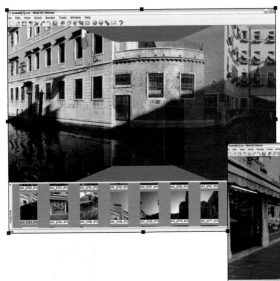

I can go to Edit → Properties whenever I like, to confirm that Stitcher has correctly calculated the focal length (about 27.2mm). Because this calculation is done automatically, Stitcher will sometimes suggest an incorrect focal length. When I type in the 27.2mm value directly, the Stitching Window display adjusts immediately.

S t a g e 4

Closing the sphere

I then continued with the two rows of photos taken at plus and minus 45°.

For this panorama, the reflections didn't pose real difficulties during the stitching stage, though they created other problems later, as you will see. What gave me trouble was the gondola in the foreground —it moved a few inches between successive pictures. I finally wound up positioning the photograph as closely as I could by using reliable, fixed reference points (the dock and the railing) and then forcing a stitch, using the Stitch→Force Stitch Image command (keyboard shortcut: Ctrl-Enter).

The manipulations were the same as those for the first row of photos. When I wasn't sure of a picture's correct position, I expanded the display to full screen, using the Windows→Full Screen command (keyboard shortcut: Spacebar).

In this particular panorama, one of the main problems was the presence of water! The surface of Venice's canals is seldom rough, but the reflections of the buildings— and the gondolas themselves, of course—have an annoying habit of moving in unpredictable ways. This forced Stitcher to do a lot of adjusting from one picture to the next.

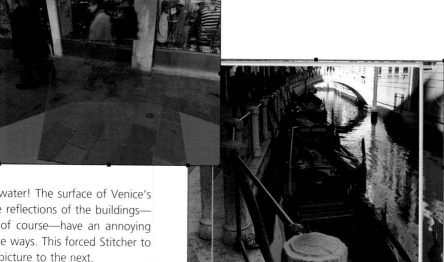

One way to get a sneak peak at a stitched section is to launch a partial planar render with Render → Proof Preview.

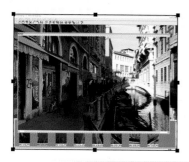

With Stitcher 4 it's very easy to see which images have been force-stitched — their thumbnails in the Image Strip have little orange markers instead of green ones.

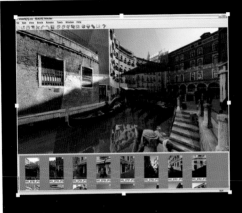

I now had to position the final two photographs, the shots of the sky and the ground.

The zenith shot moved into place without any trouble, but the nadir was more problematic. All I knew for sure was that the lens entry point was probably off-center compared to the other photos.

If I tried to stitch the photos as is, it might trip up Stitcher. Working from this new (probably incorrect) value, the program would recalculate the focal length—and thus the positioning—of all the pictures. So I put off positioning the nadir shot, and added it later in Photoshop.

If I change the angle of my panorama, and therefore lose its alignment, all I have to do is click on Tools → Go Back to Defined Horizon to automatically realign the picture.

This photograph of the Orseolo Basin had a lot of contrasts—not just shapes and textures, but areas of light and dark—which influence the way colors look. Stitcher was helpful in smoothing the overall colors, and it significantly reduced the variations in brightness.

Before running a render, I needed to straighten out the panorama. I chose vertical lines I knew were correct (doorways and the corners of buildings) and drew vertical lines over them with the cursor. When I pressed Enter, Stitcher aligned the panorama automatically. If I didn't like the result, I could have started over. Once I defined the vertical lines (and therefore the horizon), the Align Panorama icon appeared at the lower right of the Stitching Window.

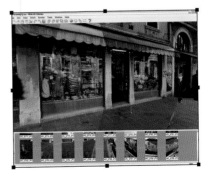

S t a g e 5

Rendering and export

The "montage-assembly" in Stitcher took less than 30 minutes. It was now time to render the panorama. I always start by making a render in Cubic QuickTime VR (Cubic QTVR) to check the quality of the montage and spot any mistakes I may have missed during partial renders. Depending on the result, this "rough draft" lets me modify the stitch between certain photographs, or readjust the horizon.

Stitcher 3.5's Artifact Removal tool can eliminate certain artifacts; for example, if objects or people move between two shots. Renamed the Stencil tool in Version 4, it has been completely rethought and greatly improved. It now spares you from using another graphic application to get rid of imperfections.

With this particular photograph, I immediately noticed that the reflections on the water looked wrong. As I feared, the reflections of the building façades overlapped in ways that made no sense at all, greatly complicating the appearance of the photograph and robbing it of all plausibility.

If I had been using Stitcher 3.5, the jig would have been up at this point, because that version's Artifact Removal tool can't handle this kind of problem. Luckily, I had a brand-new option available in Stitcher 4.

With Version 4, Stitcher can also export panoramas in PSD format. It exports multi-layer files, turning each photograph into a layer with its own layer mask. This remarkable advance gives you much greater post-production control than the previous version, and enhances your creativity in unusual and satisfying ways.

Recalculation time has suffered, of course, and the size of the images produced has ballooned. But the added value is worth these annoyances; I'd now find it impossible to work with the earlier version!

I selected the Cubic export type in Photoshop (PSD) format, and chose 3600 pixels for both width and height. In a "flattened sphere" format, this would be the equivalent of 14400 x 7200 pixels. The big advantage of a Cubic export is the ability to re-work the zenith and the nadir in Photoshop without the excessive distortion caused by a spherical projection.

I identified the folder in which I wanted Stitcher to save the rendering, and pushed the Render button. Stitcher exported six separate files, which corresponded to the six faces of a cube.

It took my 2.4 GHz Pentium 4 about 60 minutes to calculate and output the six sides of the cube (each file was about 160 MB). When I was satisfied with the quality of the six faces, I closed Stitcher and launched Photoshop CS.

If Stitcher requires you to name your file, it will differentiate the six faces of the cube by adding one of the following extensions to the name you select. They are easy to remember:

front face:	*filename_f*
right-hand face:	*filename_r*
back face:	*filename_b*
left-hand face:	*filename_l*
zenith:	*filename_u*
nadir:	*filename_d*

Stitcher 4 has a useful Best Rendering Size option. It analyzes the number of pixels in the photo, multiplied by the number of pictures, and suggests the biggest output possible without removing or creating pixels. For my panorama, Stitcher suggested a maximum size of 3756 x 3756 pixels, or 15024 x 7512 pixels laid flat.

Stage 6

Post-production

I opened the images in Photoshop separately. The enormous advantage of working with multi-layered files that include layer masks is that you can manipulate the photographs without modifying the pixels.

I chose a soft Brush shape, set its opacity to 50%, and used it to paint on the layer mask. I wanted to increase the picture's opacity, so I used white. As I gradually painted over the character's legs, the area I wanted to see began to appear.

A layer mask is a grayscale image. Everything that's painted black is masked; everything that's painted white will show through. By adjusting my brush's opacity and the percentage of gray, I could subtly change the degree of transparency. The principle is the same whether you are "resurrecting" or "burying" a detail.

I first worked on the ghostly passersby walking along the dock. I located the layer with the man in the dark coat, and clicked the thumbnail of its layer mask in the Layers palette. From then on, I worked in grayscale mode. The foreground and background colors disappeared in the Tools palette, leaving only black and white.

I usually prefer to work at 50% opacity. This forces me to paint twice as many brushstrokes, of course, but it has the advantage of letting me work gently, thereby preserving the naturalness of the overlay.

Stage 6

Refining the pictures was a matter of manipulating the Brush tool and working in grayscale (thanks to the layer masks), without modifying a single pixel on the images.

I have to admit that dealing with the water reflections was pretty tedious. The number of reflections (and their complexity) made it hard to create areas that made sense visually. Yet all of my panorama's realism depended on this painstaking work, so every detail took on enormous importance. Of the four hours I spent in Photoshop, nearly three were devoted just to fixing the reflections! And the size and weight of the images didn't let me work very quickly.

If you're likewise dealing with elephantine images, crop the image and just work on that section. Select the desired area and crop the picture (Image→Crop), being careful to save it with a different file name. Once you finish your modifications, open the original file and stick the cropped copy you've worked on over the original selected area. This trick lets you work on huge files even on an underpowered computer.

I had to be very careful in placing the nadir shot.

Having eliminated the artifacts, I then moved on to the nadir—the troublesome picture of the ground.

Because I hadn't assembled the nadir in Stitcher, the program exported an image with a blank hole in the middle. I now imported the nadir picture, reduced the layer's opacity to about 70%, and manually transformed it so it matched the main image. After a few modifications, I refined the transformation by using Edit→Transform→Distort.

I slid that layer under all the others. I could have used the layer masks on the upper layers to erase my tripod, had it been visible in the nadir picture.

I tweaked the color by creating a Curves adjustment layer (Layer→New Adjustment Layer→Curves) and worked on the layer mask, carefully erasing any remaining seams.

S t a g e 7

Finishing touches

Stitcher 4 is not only a panorama montage program; it also does conversions. To avoid any unpleasant surprises, I first had it create a document in Cubic QTVR format so I could check for any mistakes made in Photoshop (Tools➤Panorama Conversion). I chose one of the six faces (it doesn't matter which one) and specified the Cubic QTVR export type, leaving the initial size unchanged.

I thought the picture looked OK, so I went on to the next stage. Here, I asked Stitcher to produce a new export, transforming the six 3600 x 3600-pixel files into a single rectangular file in a 2:1 ratio (in this case, 14400 x 7200 pixels).

The advantage of having this new image is that I would be able to make adjustments—such as adjusting Curves or Levels—uniformly over the entire panorama.

I again used Tools➤Panorama Conversion, chose one of the six faces, and specified Spherical as the export type. I chose TIF for the output format, since PSD was no longer an option.

I finally looked at the whole thing—it was more than 520 MB! Thanks to my Canon EOS 300D's CCD sensor and its 17-40mm lens, I can capture intense colors and detail. I only needed a minor Curves adjustment to bring out a few more details in the shadows.

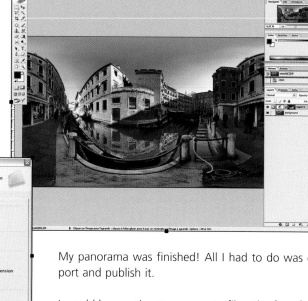

My panorama was finished! All I had to do was export and publish it.

I would be creating two separate files: the first, for a CD-ROM, would be about 6 MB; the second, for the Web, had to be no bigger than 2.5 MB.

When the conversion was finished, I temporarily closed Stitcher and returned to Photoshop.

The final export

In Stitcher, I again went back to Tools→Panorama Conversion, but this time chose Cubic QTVR as an export format, in normal JPEG format, without changing the 3600 x 3600-pixel-per-cube face file size. The resulting file was 6 MB—the size I had anticipated for the CD-ROM QTVR.

To shrink the file size below the 2.5 MB threshold for the Web version, I had two choices: lower the JPEG quality in Stitcher, or reduce the size of the panorama in Photoshop. The latter seemed the more efficient solution, since JPEG compression sometimes leads to all sorts of trouble.

In Photoshop, I reduced the image size to 5400 x 2700 pixels—the equivalent of 1350 pixels per face for a cubic file. After a Save As, I launched a new Panorama Conversion in Stitcher, then applied a new conversion with medium JPEG compression.

My QTVR file was now 2.3 MB—a reasonable size for a spherical panorama aimed at users with a broadband connection. With undisguised pleasure, I invite you to spend a moment deep in the heart of "Venice serenissima." Come to *www.gillesvidal.com/orseolo.htm*.

Bon voyage! ■

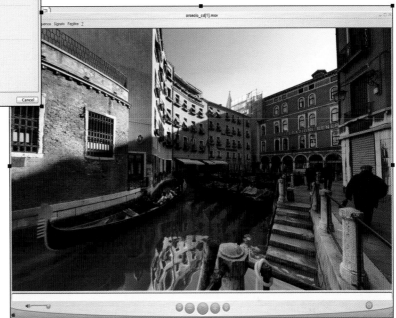

Stitcher 4 has a fast, practical interactive QuickTime VR Preview feature. It helps you not only choose the visualization window size, but also set values for maximum and minimum zoom, and for view angle.

The Authors

BERTRAND **BODIN**

Photographer

Photography is essentially "writing with light." This is what Bertrand Bodin does. He says his images exist "to awaken the senses and inform the eye." His work bears witness to a gift for capturing unique moments, especially in the natural world. Bodin's nature, sports, mountain, animal, and landscape photographs can be found in his books and on his many postcards. They are also seen around the world, thanks to magazines and photo and advertising agencies. He is currently working on a book about the nature reserves of Haute-Savoie, in the French Alps. He creates his pictures using a Canon EOS-1Ds camera and a variety of lenses.

info@bertrand-bodin.com • www.bertrand-bodin.com

ARNAUD **FRICH**

Photographer

Arnaud Frich is a professional photographer and the author of *La photographie panoramique*, published in January 2004 by éditions Eyrolles in Paris. A fan of the panoramic format since he was a child, Frich creates his images both with a dedicated panoramic camera and also by assembly. He teaches panoramic photography and color techniques, and is a beta tester for stitching software.

contact@arnaudfrichphoto.com • www.arnaudfrichphoto.com

ALBERT **LEMOINE**

Artist, photographer

After studying philosophy, Albert Lemoine became a professional photographer in 1984. He considers himself somewhat unusual in the realm of montage and digital manipulation. He came to the field late, but brought photographic skills and experience with multiple-exposure techniques. His current work is a synthesis of the two disciplines, combining the intuitive and unpredictable nature of multiple exposures with the precision and efficiency of digital tools.

albertlemoine@wanadoo.fr • http://photo.imaginaire.free.fr/

CHRISTOPHE **NOËL**

Artist, photographer

Originally trained as a mechanic, Christophe Noël sailed on the *Marion Dufresne* in 1998 to spend a year of military service in the Kerguelen Islands, in the southern Indian Ocean. He taught himself photography there, and decided to change careers when he got home to France. In 2000, he enrolled at the IRIS Center in Paris, studying photojournalism and studio photography. He then worked as a photographer's assistant for the Hachette Filipacci group and as a portrait photographer for the Opale agency. In 2003, at age 27, he exhibited some of his work in a photography project for the Seine-Saint-Denis regional council. Today, Noël creates self-portraits and settings for works of fiction in video performances and installations. He uses a 4 x 5-in. Sinar view camera and a 2 ¼ x 2 ¾-in. Mamiya, and creates his assemblies in Photoshop.

kristophenoel@yahoo.fr • http://www.syracuse.canalblog.com/

SACHA **POPOVIC**

Creative director, photographer

After working as a successful designer and photographer specializing in luxury goods, Sacha Popovic opened a creative studio named Well Done, where he is the creative director. He sees this as a way to branch out and provide an overall graphic approach for clients who prefer to work directly with creative talent, rather than through a conventional agency. Popovic has several photographic publishing projects underway, and is represented by three agencies in France and England.

rebeldesign@free.fr • sachapopovic@noos.fr • www.welldone-studio.com/

PEET **SIMARD**

Advertising photographer

A photographer for the past 25 years, Peet Simard practiced human-interest journalism and created surreal landscapes in North America and France before becoming an advertising photographer in Paris in 1990. He uses digital photography for most of his professional work, but remains faithful to film for his personal projects.

peetsimard@yahoo.com • www.parisartphoto.com

LAURENT **THION**

Photographer, web designer

A graduate of the École Estienne in Paris, Laurent Thion has worked in both digital imagery and photography for 20 years. His focus is now on developing Internet sites and CD-ROMs, and he creates interactive panoramic photos for these two media.

laurent-thion@ecliptique.com • www.ecliptique.com

GILLES **VIDAL**

Computer graphics designer, panorama photographer

Trained in design at the Beaux-Arts of Toulouse and an architect for more than 11 years, Gilles Vidal discovered the multimedia world in 1998 almost by accident. He earned a certificate as a multimedia project manager, then trained as a technician in image synthesis. Since 2000, he has concentrated on spherical panoramas, which enable him to combine the pleasure of playing with shapes and images with his desire to explore new digital horizons.

gilles@gillesvidal.com • www.gillesvidal.com

THE TRANSLATOR

WILLIAM **RODARMOR**

Translator, writer, editor

William Rodarmor is a French literary translator with a background in computers, law, photography, and sailing. Of his many translated books, *Tamata and the Alliance,* by Bernard Moitessier, won the 1996 Lewis Galantière Prize from the American Translators Association. In O'Reilly's "Designer Notebook" series, Rodarmor translated *Illustrations with Photoshop* and *Creating Photomontages with Photoshop*. A freelance book editor with a fondness for European graphic novels, he lives in Berkeley, California.

rodarmor222@aol.com • www.editorsforum.org

Studios

BERTRAND **BODIN** *Waterfalls of Ice*

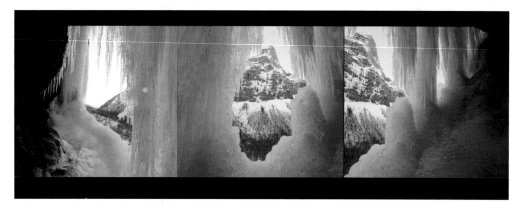

ARNAUD **FRICH** *At the Restaurant*

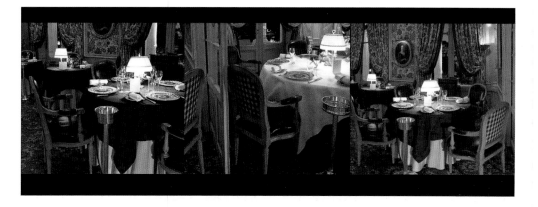

ALBERT **LEMOINE** *Frenzy at Almanarre Beach*

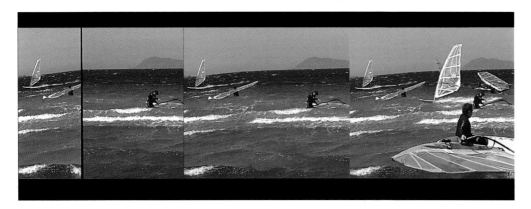

CHRISTOPHE **NOËL** *The Workshop*

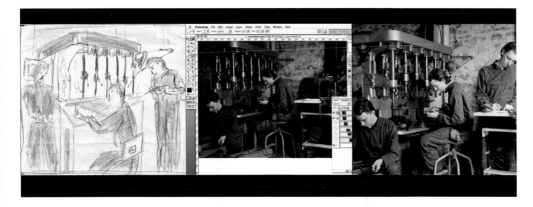

SACHA **POPOVIC** *Urban Sphere*

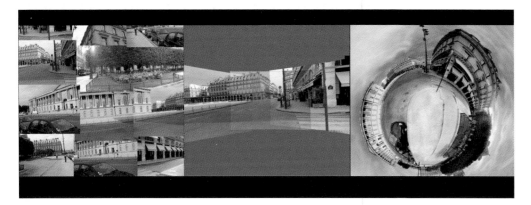

PEET **SIMARD** *On the Boulevards*

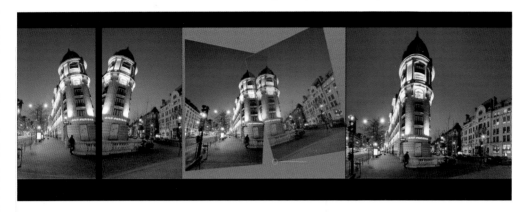

LAURENT **THION** *The Phare des Baleines Lighthouse*

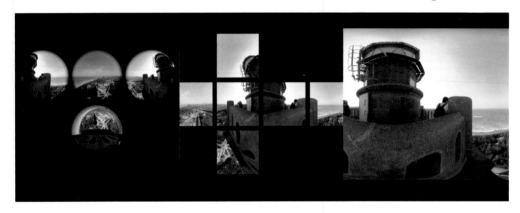

GILLES **VIDAL** *Venice: The Orseolo Basin*